DESIGNING A PHOTOGRAPH

Bermuda. Leica M-3, 35mm Summicron lens, Kodacolor II

Holland America. Leica M-3, 35mm Summicron lens, Kodacolor 100

DESIGNING A PHOTOGRAPH

by Bill Smith

*Visual techniques for
making your photographs work*

AMPHOTO
American Photographic Book Publishing
an imprint of Watson-Guptill Publications/New York

My thanks to the following for the technical expertise, care, high standards, and service that have been given me over the years, which helped make this book possible.

Cape Light, Inc.
Fine Art Color Printing
Robert Korn
46 Main Street
Orleans, Mass.

Duggal Color Lab
9 West 20th Street
New York, New York

New England School of Photography
537 Commonwealth Avenue
Boston, Massachusetts

Editorial Concept by Marisa Bulzone
Edited by Donna Marcotrigiano
Designed by Jay Anning
Graphic Production by Katherine Rosenbloom

First published 1985 in New York by AMPHOTO,
an imprint of Watson-Guptill Publications,
a division of Billboard Publications, Inc.,
1515 Broadway, New York, NY 10036

Library of Congress Cataloging in Publication Data

Smith, Bill, 1952–
 Designing a photograph.

 Includes index.
 1. Composition (Photography) 2. Photography, Artistic.
I. Title.
TR179.S65 1985 770'.1'1 84–24506
ISBN 0-8174-3775-4
ISBN 0-8174-5876-X (pbk.)

Manufactured in Singapore

6 7 8 9 10 11/97 96 95 94 93

Rhode Island. Nikon F, 100mm macro lens, Kodachrome 64

This book is dedicated to those people
whose love, friendship, support, and
belief in me made this project a reality.

Thomas Alan Brown	Betty Smith
Pamela G. Edwards	Janice A.S. Smith
Jack Carruthers	Elyse Weissberg
Goldie Selly	Michael Janowitz
Sam Smith	Dennis Connors

Carl Siembab

CONTENTS

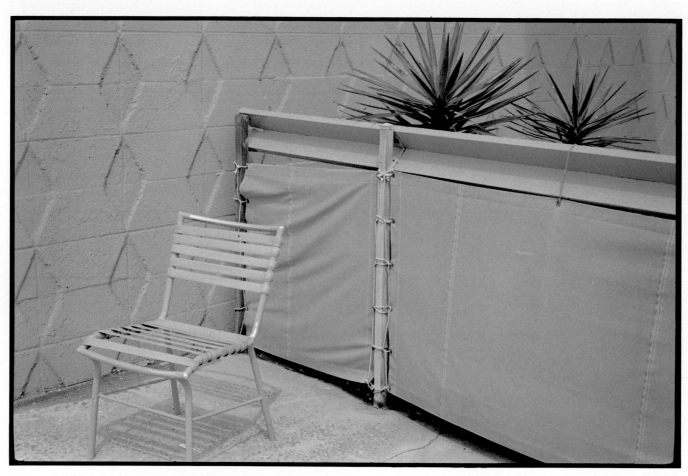

Virginia Beach, Virginia. Leica M-3, 35mm Summicron lens, Kodacolor II

Introduction

There is a certain amount of duality that exists in every moment of our lives, and every decision that we make. As you sit and wait for the movie to begin in the theatre, don't thoughts like "I really should have watered the plants?" or "Maybe I should have gone to the other movie around the corner?" or "I should have saved this movie to see with my girlfriend?" etc., run through your mind even for a brief amount of time? You may be pleased with this decision about the movie if you enjoyed it. If not, you will probably think to yourself, "I knew I should have done one of the things that I thought about before the movie began."

Photography is no different in its contradictory nature. While almost every family in the U.S.A. owns a camera, few people are good photographers. The process of taking a picture is so simple a child can do it, but a special vision is necessary to see a subject with total clarity and sum it up in 1/500 of a second. Although the image can be altered after it is on film, the amount of the alteration is limited by the process (color or black-and-white) and the image is final in its form. To see with complete vision is the one quality that separates a photographer from the casual camera user.

A camera is used to capture a moment, a feeling, to record for posterity, the future, and satisfy your ego. Yet, it must also be used with a certain objectivity. In a moment of sheer joy, the splendor of a scenic shot can be greatly reduced by the inclusion of litter, cars, and telephone wires that were not seen because of the intensity of emotion. The camera is a tool that is only as good as the eye that applies it.

By placing a camera between yourself and your subject, the experience changes radically. The photographer becomes an observer, no longer a participant. When the camera user attempts to be as much a participant as an observer, the image suffers. The responsibility and awareness of the photographer is to sense, to feel, and to capture on film the beauty and the emotion while being detached enough to view it in its entirety.

To create well-designed images, the photographer should know how the mind sees and organizes information. Having a basic understanding of how the mind works allows the photographer to design an image that communicates what he intended. In "Mind and Eye", each concept is explained in an informal manner, and then the concept is applied to a photographic situation.

The focus then turns to different techniques that can be used to expand how you look at the world with a camera. "Look Before You See" offers techniques and exercises with possible visual solutions. The exercises provide a way to sharpen your visual skills and visual awareness.

The chapter entitled "Shooting in Black-and-White" examines some of the controls in the process and their affect on the visual perception of the image. Various lighting situations are covered with the purpose of showing how to work within these boundaries and the possible solutions. In "Shooting in Color", the lighting and its effect on the final image is looked at from the perspective of how color responds to light and how to use that response in a creative way. Then, the transition between, and comparisons of, the respective strengths and weaknesses of black-and-white and color are examined.

Understanding the basic boundaries and the possibilities in the mental process is important. Yet, photography itself is a process that has an evolution, direction and self-imposed boundaries. "Photographing for Yourself" looks at this evolutionary process and attempts to provide perspective on the questions and the issues a photographer must address about his own work. Since the image produced by a person represents his vision colored by his experience, the creative process and the questions that he employs and answers are an integral part of the design and direction of the work.

"Photographing for Commercial Applications" addresses the usage and importance of photographic design as a tool in the creation of a specific communication. Since the photograph is "designed" for a particular purpose and use, some of the thoughts and perspectives of art directors have been incorporated into the text to provide an overview of the process. At first, this may seem somewhat unrelated to the previous chapters. But, the design of an advertisement employs all the concepts, boundaries, and questions that have already been discussed. The difference is that the photograph's use and

effect is calculated and consciously designed for a single purpose.

It is important to remember that photography is about light and the effects that light creates. Whether the subject is seen by light that is passive (overcast) or active (directional), it is the light that defines how the subject is rendered. As the light changes, so does the perception of the subject. Sometimes the light is "perfect," at other times it may be totally unusable. Vision and/or awareness of light is a necessity to a photographer.

Since a photograph is used for visual communication, it must have strength and clarity. To help the viewer see what is intended, the photographer incorporates a sense of design to direct the movement of the eye within the frame. This motion must be continuous and smooth, because the person who looks at a photograph wants to see it easily and not have his eye pushed or pulled around the frame.

The frame of a photograph, like the edge of a screen or painting, is a defined boundary that one must work within. A well-designed image is one in which information has either been selectively included or deleted, and that which is included must be organized in a manner that maintains the viewer's interest in a clear, uncluttered presentation. It is the photographer's responsibility to make images that are visually organized, not create pictures that the viewers must force themselves to look at. After all, the purpose behind creating photographs that have a coherent design is to allow motion to be maintained.

There is one vital element that you add to a photograph that no one else can. Your vision is unique and it influences every shot you take. Is there really anything that you will shoot that has never been photographed before? Only the way you see it will make it look different. The same statement holds true for the contents of this book. It does not cover new information. The information has already been taught in countless classrooms and has been written about in numerous books. But it does differ in the way that concepts of design and solutions to visual problems and situations are presented. In photography or any other creative endeavor, only the presentation changes, not the basic form.

As necessary as definitions, categories, and judgments are in our world, they can complicate the work of a photographer. Whether work is judged as great or as a failure is the realm and responsibility of others. It is a function of time and timing relative to the work of others. The definitions of art or commercial photographs, or categories of scenic or abstract, are necessary to others, not to the photographer. Everything should or must be someplace, fit somewhere, not just exist for the sake of what it is. For the photographer, categorizations should be accepted only for what they are, not as a determination of what the images he creates are or will be. While it is good and necessary to be praised and defined, praise should be accepted for its value, no more or less. This is a difficult task for any person to accept, but for the creative person it is a necessity if growth and exploration are the purpose of the process.

Not every photograph in this book is equal in strength or interest. But, each has the specific purpose of illustrating concepts, offering solutions to problems, and suggesting options on how to work within certain boundaries. Whether or not you like a particular image should be irrelevant to your understanding the point that it illustrates. Enjoyment of an image is as selective as your vision, but that should not inhibit the learning process. The one constant, in all of the images, is that they all show a sound sense of design.

This book offers the potential for you to create photographs closer to what you had intended. Unfortunately, it cannot make you a great photographer. Only by continuous work and a passion for the process can this be possible. A great photographer is only someone who is more consistently good than others in the profession. A passion and love of photography coupled with an endless curiosity and drive to see what more can be created are some of the characteristics of a great photographer. It does not mean you would not reach this level. It only means that it has to come from you, and neither this nor any other book or class can do it for you. But, this book does have a value, and that is to offer a way to create images with a stronger sense of design. That is a very valuable piece of knowledge to have in your control.

MIND AND EYE

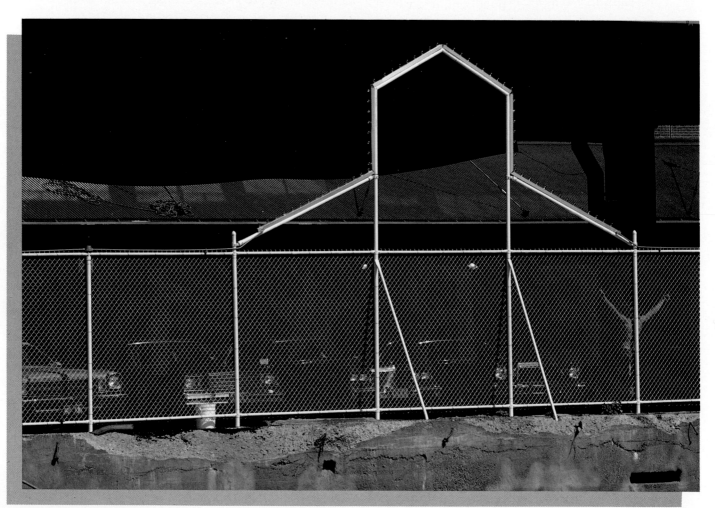

New York, New York. Nikon F-2, 100mm macro lens, Kodachrome 64

"The whole is different from the sum of its parts."

Although it may appear to be obvious, an awareness of the frame of an image is extremely important. Since the frame's edges are the boundaries by which the image is defined and limited, the photographer must be aware of all the elements, their placement, and their effect as a total unit. As a result, an excellent habit to acquire, and then continually integrate, is scanning the edges of the frame before clicking the shutter. Elements of brighter tonality can pull the eye out of the frame rather than continue visual movement. The attention given to the edges may be cut short by the need for a quick response to the scene, but the photographer must always be aware of the frame. Regardless of the time involved, it is as necessary a step in the process as checking exposure or focus.

Remember a photograph is a two-dimensional plane that is compressed from a real and tangible three-dimensional scene. A photograph has no physical depth, and details are omitted as the scene is compressed onto film. As a result, the information in the scene is selectively organized and affected by choice of lens, perspective, and cropping within the frame. A photograph is a selective representation of reality, and it freezes the scene and the moment in time. In a way, it is an illusion that is a visual communication of reality subjectively seen.

Television, movies, and photography are all forms of visual communication. Only photography relies on a single, unmoving image without benefit of sound and motion to enhance, complement, or expand its ability to reach the viewer.

Initially, a photograph must have the strength to draw the viewer's attention. Then the parts and the subtleties will maintain the viewer's interest or curiosity. A Japanese analogy applies to the effect of a good image—You see the simple beauty of the pond's surface. As you look more closely, you see the endless worlds within worlds beneath its surface. Ideally, a photograph should have this effect. A good photograph does not need an explanation. If the photograph is weak, words will not make it stronger. The photograph must communicate in a simple coherent way and not rely on words to explain, describe, or defend its message and purpose.

A good photograph relies on the organization of all the elements in the scene to create clear communication. Your vision and design affect how the image will be seen.

How and what you see is the sum of all your knowledge, experience, and memories. You bring all of this to each photograph that you shoot or see. Your eye is only a lens; it has no memory, knowledge, or experience. When you see the back of a hand, you know because of your experience there is another side to it, even though it is not visible. A baby sees only one side because no experience has informed the child that there is more than what is actually seen. Understanding how the mind organizes information during the process of seeing is invaluable. It provides the photographer with the knowledge to design an image that facilitates clear communication and motion within the frame.

The study of the process of seeing is called visual perception, an area studied by psychologists for many decades. In this chapter, the basic concepts used to describe the process of how information is organized are taken from Gestalt psychology. This is only one facet of visual perception, but it is this process that allows the picture to be seen as a single whole image. Each part of a photograph is actually seen separately. The mind's ability to group them all together allows them to be seen as one image. As Gestalt psychology states: "The whole is different from the sum of its parts."

The words "visual element" refer to anything seen as a discrete recognizable unit. This can be a person, a number, a french fry, or a horse. Visual elements vary in size, shape, color, and texture. They can be similar or dissimilar.

Over the years, I have read and heard many explanations of why and how an image is seen and designed. The section that follows is the most logical, practical, and easily understood presentation that I have found.

SELECTIVE FOCUS

The photographer has a variety of tools that can alter the design of an image. Selection of film, filtration, lens, focus, lighting, and format are dependent on the way you choose the picture to be seen. Focus defines importance by isolating the subject from the background because the eye will not remain in an area that is out of focus. Both the background as well as its relationship to the figure will be seen, but the eye will quickly return to the focused area. Even though part of the photograph is out of focus, the shapes, colors, textures, and light-to-dark relationships of the foreground and background must complement and enhance the subject. Although selective focus affects visual motion and defines importance, it is still necessary to maintain an awareness of how the figure relates to the entire frame.

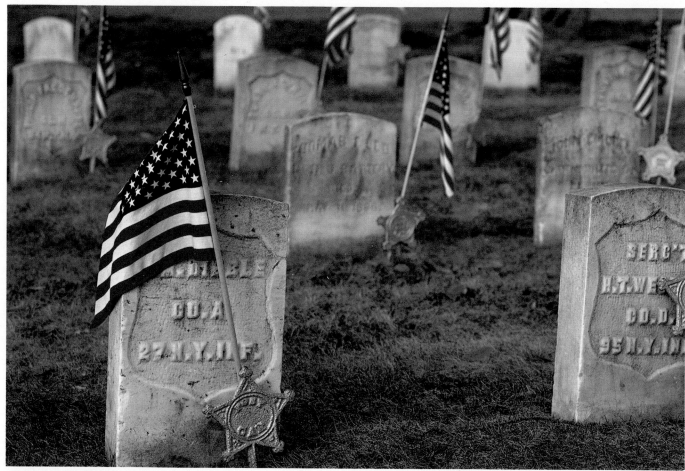

New York State. Nikon F-2, 100mm macro lens, Kodachrome 64

There are really two solutions to photographing a group of identical objects. One option is to include all or many of the objects and have them all in sharp focus. By using the repetition and a good angle, an interesting shot can be designed. The other option is illustrated here. In this case, the large amount of space between the grave markers made the inclusion of all the markers visually unacceptable. Selective focus emphasizes the importance of the flag draped across a gravestone and the symbolism of the scene. The other markers and flags in the background reinforce the fact that this flag is one of many. Only part of the marker on the right is also in focus, and it acts as a balance to the one on the left. This selective focus causes the color and the texture to become more important. To further emphasize this particular flag, you will see it is the only one that is draped, and the flag points in a different direction than all the others. Showing less creates a more powerful image.

12

New Jersey. Nikon F-2, 100mm macro lens, Kodachrome 64

Initially, your eye is drawn into the picture by the lighter tonalities in the background. By utilizing a selective focus and then positioning the fence so it overlaps and intersects these areas, the eye returns to the foreground. Additional motion between figure and ground is created by the similar tonalities of cement and water, the water stain on the cement, the eye's movement across the fence, and the fence's overlapping of the background. The selective focus creates a peaceful feeling in the shot. If the whole picture were sharp, the background would dominate the image due to its lightness. Also, the eye would jump back and forth between the two areas, creating a busy motion, and remove the subtlety that now exists. The feeling is enhanced by the balance of light-to-dark relationships on both sides of the frame.

When I first saw this scene, I was not convinced it was worth shooting. An hour later, I returned and tried to solve the problem of how to define and isolate the beauty in the scene. The difficulty was to separate all the colors, textures, and light-to-dark relationships that were similar throughout the picture. By using selective focus, it results in the separation of the tree and the window frame from the background. This illustrates one way to define and to highlight what is special within all the similarity. If the whole picture were sharp, there would be nothing to focus the eye's attention. The scene would blur into an undefined mass of tone, color, and texture.

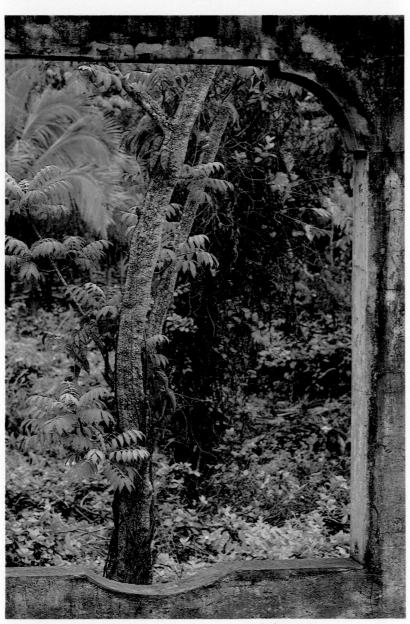

Ochos Rios, Jamaica. Nikon F-2, 100mm macro lens, Kodachrome 64

PERSPECTIVE

The lens you choose when you take a photograph is as important as any other tool you have available. A long lens (telephoto) will compress and increase the size of the image. A wide-angle lens will increase and exaggerate the feeling of depth and scale. The choice you make is critical in that it will affect how the image will be perceived. Usage of a fisheye lens or a 500mm lens will not make up for a boring subject or a bad sense of design.

Commercially lens selection is generally determined by subject, usage of the photograph, the effect that is required for the job, and the physical space limitations. Most photographers have certain lenses that they favor over others, in both a professional capacity, and for their own use. For commercial work, I prefer a 28mm and a 100mm macro, but I use a 35mm and a 100mm macro for personal work. Although a 50mm lens is called a normal lens because it gives the same angle-of-view as the human eye, I use a 35mm because it is closer to the angle-of-view that I see the world. The 100mm macro offers the compression with the capacity to move in very close. Lens preference is personal, and it is only one of a few possibilities that a photographer can utilize.

Before you get to a point that you favor one lens over another, you must first learn and test the limitations and capabilities of each lens. The best advice is to use one lens at a time. Once you know your lenses, then you will have the knowledge to further control the design and the communication of your pictures.

Jamaica. Nikon F-2, 100mm macro lens, Kodachrome 64

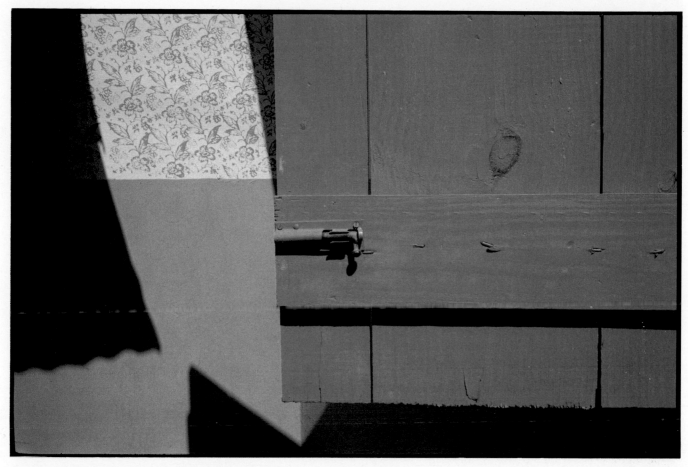

Jamaica. Leica M-3, 35mm Summicron lens, Kodacolor 100

As you look at these photographs, the effect of lens choice on a subject is quite clear. While the telephoto compresses the scene into a flat, two-dimensional image, the wide-angle accentuates the perception of depth. Both pictures use color, shape, and division of space. But, here the similarity ends.

The division of space, and compression of the image are the strengths of the telephoto shot. The wide-angle 35mm shot adds the dimension of texture and uses depth to exaggerate the division of space. In the wide-angle shot, the door is defined as a strong figure while it serves only as an element in space in the telephoto shot. In this case, the wide-angle works more effectively by adding the elements of texture and creating front-to-back movement. Both shots are as different as they are similar, but it is the wide-angle that adds the additional elements that the telephoto deletes.

FIGURE/GROUND

Different disciplines employ different words to describe the same thing. In art, positive/negative space describes the same relationship that psychologists define by *figure* (subject) and *ground* (background). The words have changed but not the relationship.

It is impossible to have a subject without a background. The function of the background is to provide a way to define the subject by giving it a context in which to exist. To a degree, this is why people hallucinate in the desert. Everything begins to look the same, there is nothing that is defined so your mind creates a figure. Since background defines the figure, awareness of the interaction of these two areas is necessary when you take a photograph.

The selection of figure/ground continually occurs in our daily lives, and involves all of the senses. For example, you are at a party. The noises include a radio playing in the background, and various conversations. At this moment, your conversation is figure; the other noises are ground. Suddenly, one of your favorite songs begins playing on the radio. Now, the radio is figure; the conversations become ground.

When you walk into a restaurant, you are suddenly presented with a vast array of odors and scents. Initially, you will attempt to define those smells which are either the least or the most familiar to you. One odor is recognized and becomes figure. You then move onto the next scent and the first odor becomes ground. Again the selection of figure is selective and continuously changing.

The same process exists for the sense of touch. When you buy a camera, aside from the technical wizardry, you change from one model to the next searching for the one that feels best in your hand. Weight and size are figure, while gadgetry is ground.

When you are having dinner, whatever is either familiar or new and unknown to your taste buds becomes the focus of your attention. You don't just taste one thing. There is a continual changing of figure/ground.

The process of figure/ground selection varies from person to person. Have you ever stood on a corner and overheard a group of tourists looking at the scene in front of them? One sees the architecture; another wants something sweet and sees the candy store. Someone else wants to write home about the tour and sees a postcard vendor.

Since each individual's perceptions are different, the photographer must constantly be aware of both figure and ground. By selection and deletion of information in the frame, a photographer creates and controls what and how the image is seen. The background is as important as the subject. They are separate yet the way they work together is critical to the success of the image.

To place your best friend in front of a telephone pole and then take the picture may not say what you want. The result may be funny, but the pole may distract and add something to the portrait that will not communicate what you had intended. As you take photographs, look first at the subject and then the background to see how it looks. If the background is busy, or the light is poor, find a better angle to shoot the picture.

The statements below define the role and relationship that exists between figure and ground in a photograph.

• Regardless of placement in the frame, figure is perceived as being closer to the viewer. Figure appears closer as the background recedes due to the lack of focus.

• The figure usually occupies a smaller amount of space in the frame than the ground. Although it may appear larger and closer due to focus and importance, it usually takes up less physical space than ground.

• Figure and ground cannot be seen simultaneously, but you can see them sequentially. When you read while you watch TV, are you really seeing both at the same time? Your attention continually changes from one to the other. You can't see both simultaneously.

• Figure is seen as having form, contour, or shape while the ground is not seen as having these characteristics.

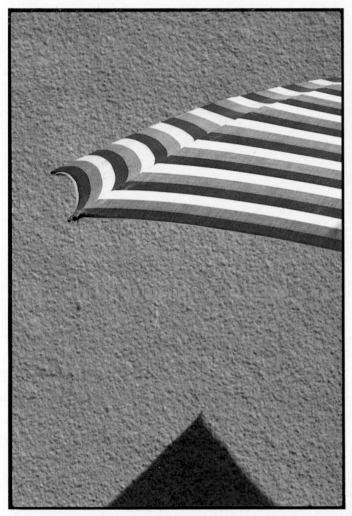

Asbury Park, New Jersey. Nikon F-2, 100mm macro lens, Kodachrome 64

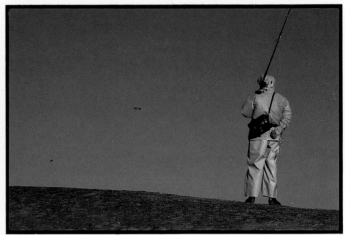

Montauk, New York. Nikon F-2, 100mm macro lens, Kodachrome 64

Separation between figure and ground is very clearly defined. The light yellow slicker against the dark blue sky creates a strong contrast. A large amount of space around the subject further emphasizes the fisherman's visual importance. Two other points bring the eye to the figure. Because the fishing pole goes out of the frame, it anchors his feet on the ground and his location in the shot. Movement from figure to ground and back is also created by the turn of the head to the left and the bird flying in his direction. The subject has shape, form, and contour. It is smaller than ground and appears closer to the viewer. As was stated previously, you cannot see both figure and ground simultaneously, but you can see them sequentially. Look at this photograph and try to see both at once. You will see that it cannot be done.

In this image, the interplay and separation between figure/ground is subtler and more complex than the previous photograph. The separation is created by selective focus plus the lighter tonality and graphic material of the umbrella contrasted against the darker wall. The interplay between the umbrella and the wall creates movement around the frame. Look at the similar texture in the umbrella and wall as well as the similar shape of the shadow at the bottom of the frame and the umbrella. This creates motion up-and-down and front-to-back. The selective focus, graphics, and brighter tone of the umbrella return the eye to the figure and prevent the eye from remaining in the background.

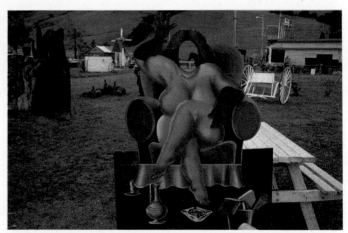

Quebec, Canada. Leica M-3, 35mm Summicron lens, Kodacolor 100

This shot is much busier than the previous examples. In this case, the bizarre nature of the figure is enhanced by the ground. Without the horse, trees, tables, and other cutouts, this image of the woman would be out of context. The additional information in the background relates to the fat lady and emphasizes the strangeness of the figure and the scene. The fat lady as figure occupies less space than the background, but she has shape, contour, and form, and appears larger and closer to the viewer.

FIGURE/GROUND FLIP

The qualities attributed to the figure such as shape, and contour, as well as being seen as closer, can only be applied to the background when it is seen as the figure. In order for this to occur what was originally seen as figure must be seen as ground.

This process of figure/ground flip occurs in our day-to-day activities. If you do two things at once, like watching television and reading the paper, your eyes shift focus back and forth from one to the other. As the television becomes the figure, it is the paper that becomes ground. When you shift your attention to the paper, it is figure, and the television is ground. Both cannot be seen simultaneously, only sequentially.

In photography, this reversal can occur through the use of strong contrast, lighter tonalities, more details, intellectual or emotional associations, or stronger shapes placed in ground rather than in the figure. A strong visual relationship between the figure/ground must be maintained to enhance motion back-and-forth.

As a technique, it can add another dimension to an image. In nature photography, a stone, a branch, or a part of the shoreline is sometimes used as a visual stepping stone to the mountains in the background. When two people are being photographed together, a stronger more contrasty light placed on the person standing in the background will create a reversal. For both of these situations, the visual motion of a figure/ground flip adds a relationship between the two areas that makes the final image more interesting. Usage of this technique is as selective as lens choice, film, or perspective.

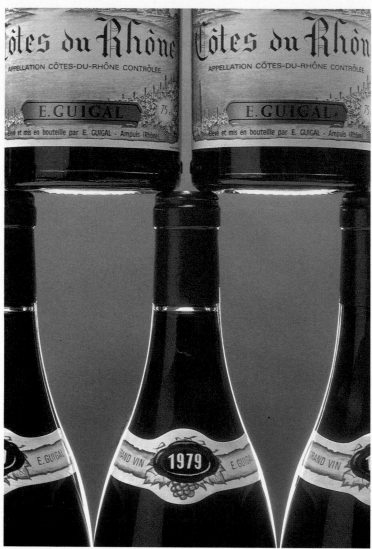

Studio Shot. Hasselblad 500cm 2¼"-square, 120mm Planar lens, Professional Ektachrome 64

At first, your eye is drawn to the highlights along the edges of the bottles. Since the bottles are easily identified, they are seen as figure. The reflections within the bottles, light and tonality of the labels, and the close positioning enhances their strength as figure so you see them as a group of similar elements. Yet, as your eye follows the lines created by the highlights on the edges of the bottles, the glass-like shape formed with background becomes visible. Now, this glass-like shape is seen as figure while the bottles become the ground.

Visual motion between these two shapes and areas is continuous and sequential. Although you may think that you can see both bottles and "glasses" simultaneously, only one shape is visible at a time. Remember that only figure is seen as having shape, form, contour, and appears closer. The ground does not have these characteristics until it is seen as figure. An intellectual association between wine and the use of glasses establishes a relationship that further enhances the possibility of seeing the shapes of the "glasses."

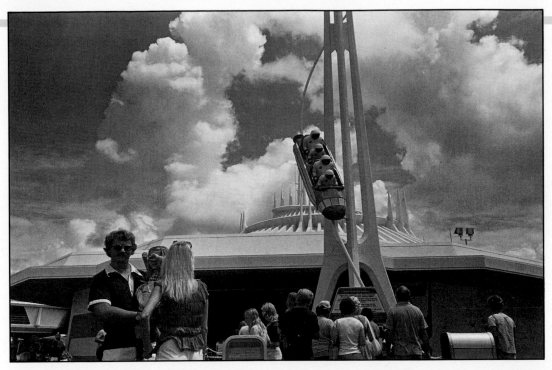

Disney World, Florida. Leica M-3, 35mm Summicron lens, Tri-X

A surrealistic quality is the effect created by this figure/ground flip. The figure (people in foreground) becomes the ground as the lighter tonality of the clouds, strong circular shapes in the clouds and sky, and the good contrast of light-to-dark relationships allow the ground to now be seen as figure. This reversal and the spaceship's appearance of returning from the clouds present a surrealistic scene. At this point, the entire bottom half of the frame acts as a necessary visual anchor. It provides the reality of the place, and its contrast against the illusion above facilitates motion front-to-back. Furthermore, it enhances the relationship and ambiguity between the two worlds.

Take a piece of paper and try cropping the bottom half of the frame at different places. Regardless of how you try to crop it, the bottom half of the frame is necessary to give the scene a context and contrast to the world above.

There are a number of visual relationships that facilitate movement from front-to-back. Certain points are important to cover now. Note the similarity of the three people with sunglasses and the spacemen wearing visors. Just as the hole in the clouds frames the ship and crew, look at the man facing the camera. His head is framed by the clouds. The people facing towards the exhibit bring your eye back to the spacemen and the clouds.

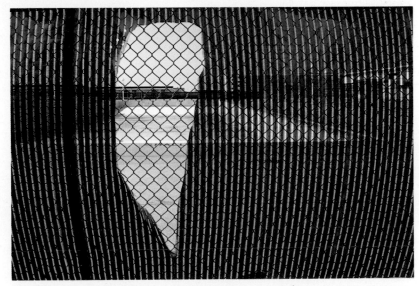

Long Island, New York. Nikon F-2, 28mm lens, Kodachrome 64

The strong curved shape of the hole in the screen acts as a frame as well as an entryway to the background. The combination of lighter tonalities and the spaces between the mesh screen permits your eye to see the details and shapes in the background as the figure. This visual flip from front-to-back does not keep the eye in one area. Since the fence overlaps and allows perception of the background, visual motion back-and-forth between these areas is continuous.

Other visual relationships work to enhance the interaction and separation between the two planes. Separation is created by the curved shapes of the mesh and hole, not repeated, and in contrast to, the rectangular shapes of the background. At the same time, there is the overlapping of square shapes in the chain links of the fence that is repeated in the pool, windows, posts, and buildings. This relationship of similar shapes repeated in both areas adds to the motion between the foreground and background. In addition, a red area in the hole is repeated in the red pole and the window on the right side of the frame. Grouping by similar shapes and color reinforces the relationship between both areas and creates movement within the frame.

PROXIMITY

Your best friend of many years is in from out of town and you decide you want a picture for the photo album. As you click the shutter, the scene is compressed onto the two-dimensional plane of the film. The telephone pole located in the background now looks like it is growing out of your friend's head. Because they are so close (proximity), the mind groups the head and pole and sees them as related. Unfortunately, this effect is probably not what was intended. If you paid attention to the background, the friend could have been moved right or left so that the proximity would be too great to allow you to group the two together. Compression of foreground and background increases as the focal length of the lens increases. As a result, extra attention should be paid to the relationships created between figure and ground as the focal length of the lens increases.

When two or more visual elements are in close proximity, they are grouped and seen as being related and/or in a pattern. This visual association, due to proximity, creates movements side-to-side, up-and-down, and front-to-back. Because of the range of motion that can be created within the frame, this is a valuable tool that can be used by the photographer to affect what and how the photograph is seen.

Proximity plays a fundamental role in our perceptions in our day to day existence. Memory, comparison, learning, and reading are all dependent on good proximity. In fact, as you read this section you will find that good proximity is necessary to reading. When the letters aretooclose together it is not as incomprehensible as when they are spaced too far or at irr egular intervals. Formation of the words and groupings of similar elements in a pattern (the word) can only be easily seen when they are in good proximity. Phone numbers, the charges on a bill, a price of a product, captions for photographs, to name only a few, rely on proximity to create an order that is logical and coherent.

Any form of comparison is enhanced by having the two elements close enough together to form a conclusion. A man who is seven feet tall does appear large when he stands in a crowd. In a field of wheat, with nothing nearby (poor proximity) to compare him against he does not seem unusually large. Quality and choice of a product is easier when both products can be compared side by side. You buy one apple over the others because it looks better in comparison.

When you judge the quality of your photographs when printing, placing them side by side (good proximity) is necessary to provide you with a way to see what to alter in the next print. A frame of reference is created by placing them together. This makes comparison and judgment easier.

Our memory is triggered by proximity. This grouping is determined by time not by virtue of being related. For example, when you misplace your car keys or wallet, you retrace your steps to give you possible clues as to where you might have left it. Movement during that time period is grouped together, so that you can remember where you have been since you saw the object the last time.

The sales of a product, whether in a store or in advertising, rely on proximity to make associations and comparison. In a lipstick ad, a product shot allows the viewer to associate the lipstick with the images of the beautiful and expensive women in the main illustration. Association by proximity is used to illustrate many points about a product including an image of how consumers wish to see themselves. Proximity allows these associations to be made and sell the product in a variety of different ways.

For you to follow the story and sequence of scenes in a movie or a television show, good proximity of elements in time and space is necessary. There has to be an order of sequence and time for the viewer to understand the story. If there is no link between the sequences, the story will lose its continuity and be seen as a fragment, not as a whole story.

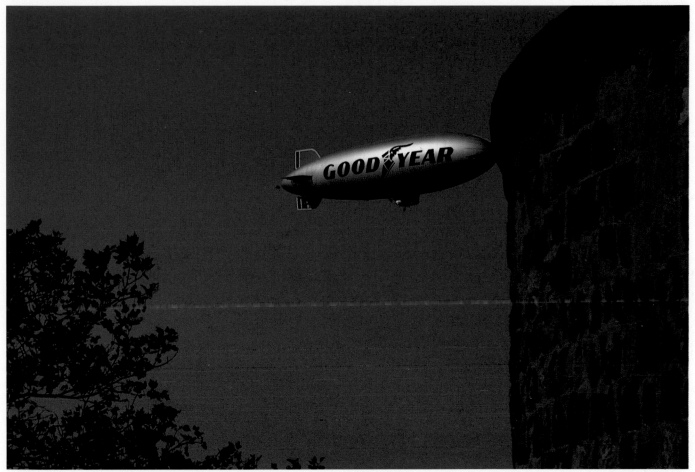

New York, New York. Nikon F-2, 200mm lens, Kodachrome 64

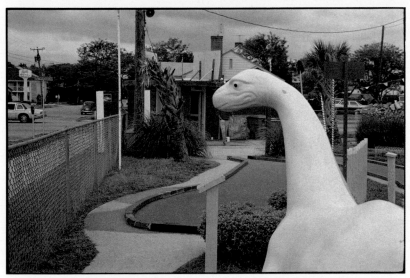

Virginia Beach, Virginia. Leica M-3, 35mm Summicron lens, Kodacolor 100

Compression, through the use of a telephoto lens, on film makes this blimp look like it has become stuck to the wall. Proximity of the two elements establishes the grouping of the two as being related, and results in visual motion side-to-side. This grouping and association creates an incongruous image that is humorous. In this example, however, the effect was intentional. Be aware of the background and how it affects and relates to the subject. If the blimp was located in the center of the frame, proximity would have been denied. The result would not have been amusing, only a literal shot of a blimp in the sky. Note the similar shape of the curve in the blimp is found in the wall and trees as well. Consequently, your eye groups the similar shapes creating movement around the frame. This concept and its role in perception and design is discussed in the section on "Similarity." (page 22)

Again, proximity has been used to create a humorous shot, but here it facilitates grouping and motion from front-to-back. The positioning of the dinosaur's head over the man's body creates the impression that the man is being consumed by the creature. Additional motion front-to-back is caused by the grouping of similar shapes—a curve repeated in the body, neck, and head of the dinosaur, the putting green, tops of the trees, and grass.

LIGHT-TO-DARK RELATIONSHIPS

This section examines three separate but interrelated concepts and their effect on visual organization and motion of a photograph. The first concept deals with *proximity and area*. A shape is formed by an area having a boundary that is created by an edge or line. Simply stated, without a line or edge to define it, you cannot see a circle, square, or rectangle on a blank piece of paper. The smaller a shape is, created by greater proximity of edge or line, the greater the possibility of it being seen as figure.

The second concept involves *area and contrast*. Strong contrast in tonality, like black against white, creates a solid separation and definition of figure/ground. But, it is the size of the elements in conjunction with contrast that affects what is seen as figure or ground. A small area with good contrast will be seen as figure, and ground will be defined by these criteria. When the size is equal and contrast is strong, your eye will flip from one area to another. When you look at the American flag, you will see the stars because of size, contrast, and similar shape. Then you move to the stripes in the background. Yet, as you look at the stripes, the strong contrast and equal size result in your eye

not being able to see either the red or white stripes as figure. Your eye moves back-and-forth between the two, but grouping to be seen as figure is only possible with the stars. Remember these two concepts do not exclusively define what is seen as figure. Characteristics like shape, size, color, texture, placement (complete or incomplete), have an added effect on perception of figure and ground.

Finally, every area of space has a specific brightness which also influences light-to-dark relationships. One object is seen as light while another appears dark. This perception is based on proximity, area, and contrast. A small white dog looks more brilliant against a dark building than a large white dog in a bright, light-toned room. The sum of all the areas arranged and seen by similar tonality creates a balance or visual rhythm.

For this section, two black-and-white photographs have been used to illustrate how these concepts affect your perception of an image. Without the added elements of color, it is easier to understand these concepts. But, it is only to make understanding the application easier; the same concepts have an effect and are relevant when looking at a color photograph.

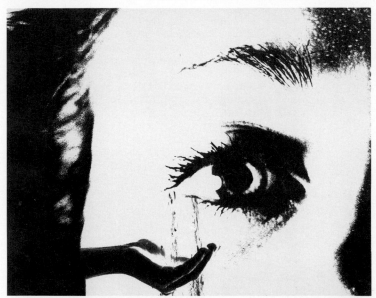

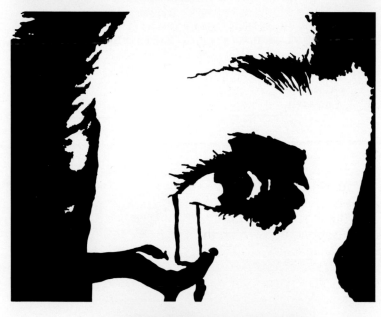

Studio. Toyo 4 × 5 Camera, 150mm Symmar lens, Tri-X Pan Professional & Kodalith

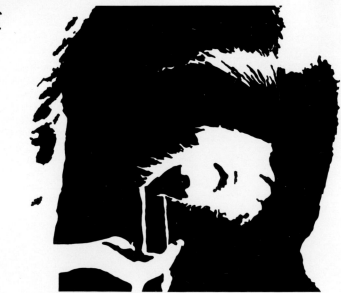

This image is a combination print that was shot in the studio and put together in the darkroom. Initially, your attention is drawn to the white areas in the eye. They are smaller, have good proximity, and strong contrast. The black shapes that create the eye are seen for the same reasons. These shapes are larger than the white areas in the eye but smaller than the surrounding white area of the face. First proximity, then contrast and sizes, lead your eye to the tears and down to the hand. The combination of these two concepts allows you to see figure (eye, tears, and hand) against the background (face, hair, and edge of face). But it is the initial response to the parts as figure that allows you to group them and form the whole picture.

The strong contrast of tonalities helps to separate figure and ground. However, the relative distribution of these areas within the frame creates a visual rhythm or balance. A tracing of the areas that are white have been outlined on tracing paper. Details are not important here, only the shapes of the areas and their placement are being considered. Areas in black have been outlined and shaded in the other tracing. The shapes in both tracings are defined by each other, yet each tracing has a rhythm that is established and balanced by the rhythm of its opposite tonality.

First, look at the edges of the frame in both tracings. The white outline defines the top and bottom while the sides are black. A basic balance has been created by the distribution of tonality.

The photograph and tracings of the eye and tears provided a way to examine the basic relationships of shapes and motion when divided into black-and-white groupings.

Black Tracing: Look at how the white areas on the left balance the motion and answer the shapes in black. It acts as a way to return to the eye because of the similar shape. The motion and the shape of the black areas is stronger and more continuous. The strong curve of the eye is repeated in the eyebrow, left side of the frame, top and bottom of eye, hand, and top left side of the picture. There is a continuous line between the shapes of the eye to the water, hand and hair on the left side of the face.

White Tracing: Overall, the white areas and their shapes are not as strongly defined as those seen in the black tracing. But, the shapes in the eye and palm of the hand repeat the dominant shape seen in black. Other than the white outlines on the left answering the black shapes in the eye, the remainder of the white shape is static in answer to the strong shapes and motion of the black areas.

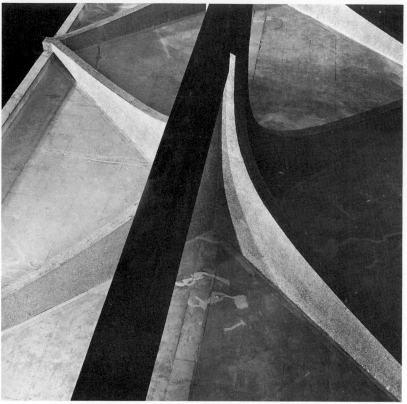

Boston, Massachusetts. Rolleiflex 2¼"-square, 80mm Zeiss Planar lens, Tri-X Pan Professional

Because the range of tones are an integral part of a photograph, this image has been broken down into three tracings. White areas and light-gray areas are only outlined, while the areas containing mid-gray in one tracing, and black and dark gray in the other are outlined and shaded in. The division makes it possible to see the shapes and motion they have separately and as a whole.

A continuous motion within the frame is created by the repetition of similar shapes. Actually, the light-to-dark relationships further define motion by separating the shapes through tonality. At first, your eye is drawn to the small white area strongly contrasted by the black beam. Due to the good proximity and smaller size of the other white shapes and light-gray shapes, your eye groups them as figure and this creates motion. Proximity and area, and contrast and area allow these areas to be seen as figure.

Look at the tracing of these white areas and you can see the balance, rhythm, and motion that they create. These shapes are similar to those found in the other tracings. A relationship of similar shapes in figure (white areas) and ground (black and mid-gray areas) creates motion between the two.

As you look at the photograph again you will see that the visual transition between mid-gray areas and black and dark gray areas is easier than movement to the white areas.

Black Tracing: The spaces between the shaded areas are seen first by your eye. The empty space on the left does not allow motion around the whole frame. Otherwise, the similar shapes and balance in the other portions of the frame is fine.

Gray Tracing: In this tracing, the empty spaces on the bottom left and right side of the frame create an overall imbalance. The similar shapes and visual relationships between these areas are good. It is, as the black tracing, incomplete.

White Tracing: This is the one tracing that has balance and good motion. Coupled with area, contrast and proximity, it is easy to see why it is seen as figure.

Together, these three tracings form a jigsaw puzzle of pieces divided into shapes according to tonality. When you look through the camera and set the lens out of focus, you can see the shapes within an image. Just as the tracings define the light-to-dark relationships, the image you see out of focus can tell you as you shoot whether an image has strong tonal relationships and visual motion.

SIMILARITY AND PROXIMITY

The grouping of elements according to similarity and proximity has already been examined separately in this chapter. However, those elements that are similar and in good proximity add another relationship. Be aware of the fact that elements that are similar in position or in size, and have good proximity, may also be seen as similar in shape. For example, a pair of hands resting on hips are likely to be seen and grouped according to the similar shapes of the triangles that they create.

Another aspect of this concept is similarity of meaning. The association made between a product, and the results and benefits of its use, plays a very large role in advertising. For example, most ads imply or infer that if you use the product you will have fun, be like (or already are like) the people shown in the photograph. Cosmetics ads rely on the image created to generate sales of their product. Ideally, the image fits how consumers see or would like to see themselves, and consequently, affects the consumer's decision to purchase the product. The one relationship that establishes the similarity of meaning that is perceived is the inclusion of a photograph showing the product. Your eye sees a woman wearing a certain type of make-up. A handsome man is standing next to her. You put the two together, and come to the conclusion that this is how you will see yourself, or be seen, if you use that make-up. When done effectively, it creates a lasting image in the consumer's mind. The campaign created for Marlboro is so well established that as soon as the cowboy with a cigarette is seen, you immediately think of the Marlboro Man.

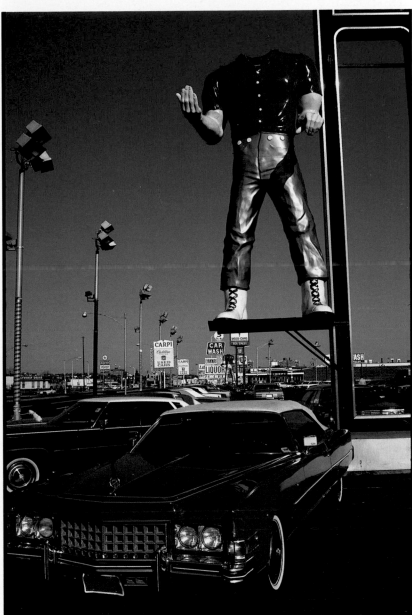

Revere, Massachusetts. Nikon F-2, 28mm lens, Kodachrome 64

A certain incongruous quality exists when you have a giant, headless lumberjack standing guard over a Cadillac. If the head were in place, as you would expect it to be, the result would be funny. But the lumberjack in the background also has a missing head which makes the scene absurd.

Similarity and proximity establish a number of groupings that lead the eye within the frame. Lights, signs, and posts are all rectangular and their closeness facilitates motion due to grouping. The white line of the cars is repeated in the silver lines in the pole. There are white lines on the road, lines in the poles and the wires in the background. As you look at the giant, you will see triangles formed by the support beams, shoelaces, legs, the collar. The hood of the car, the fender, bumper, and its shadow also create triangles. Repetition of similar color in good proximity assists your eye's motion around the frame. The top and right side of the frame are uncluttered and serve to balance the busy quality on the opposite sides of the frame. Incongruity is the initial visual draw of this shot, but it is the similarity and proximity that maintain movement.

SIMILAR SHAPE

You decide to spend the day at the beach. You look at the people, birds, and boats that are on the beach and in the water. Unconsciously, you divide these subjects into groups, according to shape. The beautiful body of a woman catches your eye as she walks along the shore. Your eye then scans the beach for other women. As your eye roams the scene, you see a woman accompanied by a fat man.

Then your eye proceeds to search for other people with a similar shape. Then, the boats are seen as a group, and later, are divided into the different shapes.

You "read" a photograph in the same way. Shapes that are similar are grouped, form patterns, and this creates motion. This organization by similar shape is a continuous part of our daily lives.

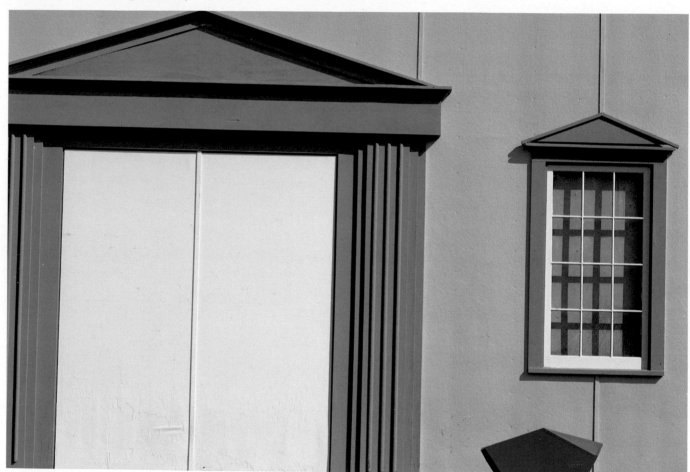

Rye, New York. Nikon F-2, 100mm macro lens, Kodachrome 64

The visual motion of this photograph relies on the repetition of similar shapes throughout the frame. The picture is filled with rectangles and triangles of various sizes. This grouping of shapes leads the eye side-to-side and up-and-down.

Rectangular shapes are found in the door. The lines in the door frame form rectangle after rectangle. The window, the panes, and the shadows cast by the frames of the panes, are also rectangular in shape. This allows your eye to move across the frame from the door, to the wall, to the window, and back again to the door. It is the rectangular shape of the wall between the door and window

that creates a visual bridge from one area to the next. Within the window, the repetition of rectangular shapes and shadows creates movement in a vertical and horizontal direction.

The shape of a triangle is seen in the frame above the door and above the window, the triangles within those frames, the top left corner, the top of the trash can, and the intersection of the can and wall. Repetition creates movement from door frame, to window frame, to container top, and back to the window frame.

Identifying these shapes and their placement helps illustrate how similar shapes can result in visual motion.

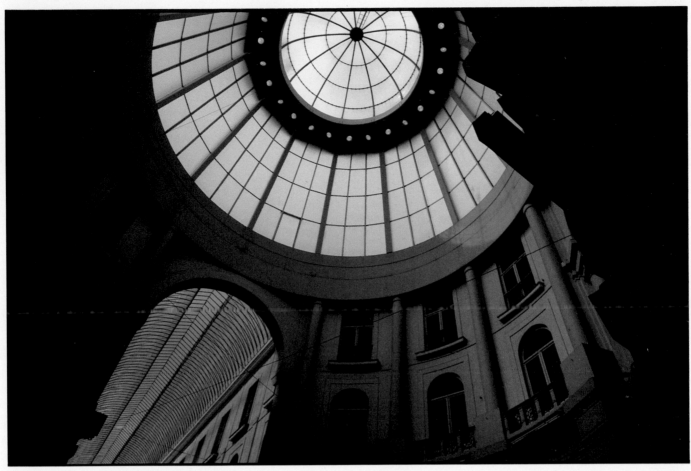

Brussels, Belgium. Nikon F-2, 28mm lens, Kodachrome 64

Compared to the simplicity and two-dimensional quality of the other image, this shot appears very complex. Both rely on the grouping of similar shapes as the primary way to foster visual motion. In this shot, rectangles, circles, and triangles are repeated continuously within the frame. This facilitates movement up-and-down and side-to-side.

The shape of the circle is seen in the dome, inside the dome, and the half-circle in the circles, roof, and windows. As the wires criss-cross through the frame, they create numerous triangles formed with the background. The wires and the shapes they create lead the eye to the triangles in the wall and the roof on the left side of the frame. Repetition of a rectangle in this wall, windows, pillars, frames around the windows, roof, balcony, post, window ledge, and space between the windows is the first shape that begins visual motion.

SIMILAR SIZE

When you walk into a clothing store, you will see a logic in the organization of the clothes. You can find what you are looking for with a minimum amount of effort. The styles on the rack are all different, but due to the similarity of size, you see the coats as being related. Once you see them as related, your mind groups them together and can see them as patterns. It is this ability to group and see in a pattern that allows your eye to move along the rack. Consider how long it takes to shop during a sale when you must stop and check the size of each item before you can try it on. This process of organization by similar size is a constant in our daily lives. Cars, pizzas, shoes, pool cues, prices, cars, televisions, and people are all organized according to size. Think of how much attention a midget or an extremely tall person can generate in a crowd. Your eye stops, and you focus your attention on the dissimilar size of these people in comparison to the rest of the group. After you have noticed these people, your eye continues to scan in a horizontal, vertical, or diagonal motion across their faces.

The knowledge that grouping can result in seeing in patterns offers another insight into how the mind will read and organize the information in a photograph. Consequently, visual motion can be in a vertical, horizontal, diagonal, or circular pattern. Both of the examples rely heavily on grouping by size into patterns to create movement within the frame.

Barbados. Nikon F-2, 100mm macro lens, Kodachrome 64

As you look at this photograph, your eye is struck by the continuous repetition of the shape of a rectangle. It is, however, the grouping by size, as well as color, that establishes the visual movement side-to-side and top-to-bottom.

Similar-size relationships are strongly defined. Identical horizontal slats are on either side of the door. A black frame around window and door, and the tan strip below the door bell, are similar in size. The windows and the wood inserts in the door are identical. The step below the doorway, the space in the bottom left-center, and the doorway all repeat a space similar in size.

Grouping is reinforced by similarity of color and texture. For example, the frames are all black, the horizontal slats are beige, and the windows are green, and have the same surface texture.

The similar shape of the door bell and light bulb, and, differently, in the hinges and handle, serve as a way to break the repetition of the rectangle.

Barbados. Nikon F-2, 100mm macro lens, Kodachrome 64

All photographs rely on more than one grouping of elements to create visual motion. As much as this image relies on more than one grouping, it is the similarity of size that is seen first.

Due to its smaller size and contrast, the space between the pillars is a strong element. The red-brown edges of the posts and the lines of shadows in the bottom center and right, and far right side repeat the size. All red areas are of the same size, shape, and color. The patch of light between the pillars is the same size. The angles caused by the shadows on the pillars right and left and between the posts on the left are similar in size. A patch of blue is seen in the background (far right) of the same size and shape in the posts and sides of smaller pillars on left. As you look at the bottom right corner, the space is divided into blocks of space that are equal in size and shape. Large shadows of similar size and shape are framed by the two center posts to the right and left.

SIMILAR TEXTURE

You are about to begin the paint job that you neglected. As you look for the sandpaper you need, which has been divided according to texture, you group the paper's texture according to the phases of the job. Just as paints are divided according to the texture they produce so are other products divided by texture to ease the customer's search when texture is of primary importance. Your mind groups elements according to similarity of texture, and this aids in grouping and seeing patterns.

This approach to grouping can be applied to photography. A sensory association, however, is made between what is seen and the memory of how it actually feels to the touch. For example, if you see an object that is wet, you perceive it as being smooth.

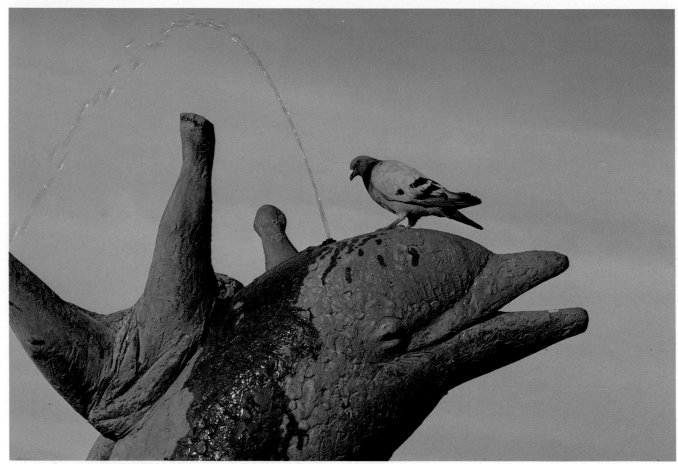

Den Hague, Holland. Nikon F-2, 100mm macro lens, Kodachrome 64

There is something a little strange about this shot. Instead of the statue looking more animated, the bird, which is real, looks like a living statue. The texture, tone, and color are so similar that they seem to blend together. Your knowledge of which one is really alive, the water coming out of the dolphin, and the red in the bird's eye separates the two. Repetition of similar shapes occurs in both dolphin and the pigeon. The shape of the dolphin's mouth is repeated in the bird's tail feathers and feet. The curve of the dolphin's head is answered by the curve in the underbelly of the bird as well as the curve of the water. The beak and the feet of the pigeon are also in good proximity to the water.

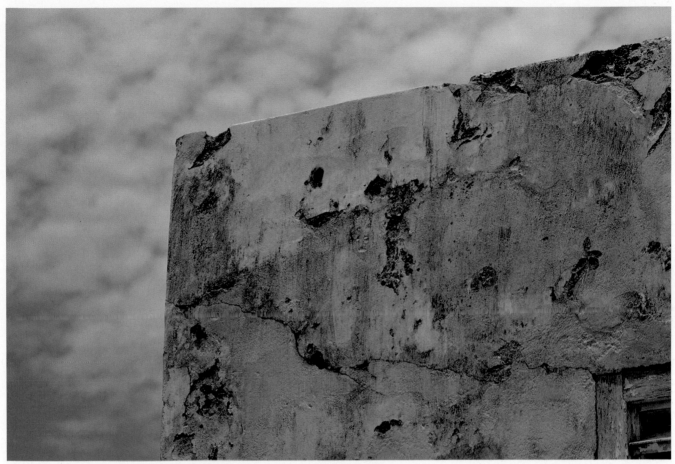

Barbados. Nikon F-2, 100mm macro lens, Kodachrome 64

Selective focus and the rectangular shape of the wall create the separation between figure/ground. The texture and shapes in both the wall and the sky are such that if both were sharp, they would blend together. Here, separation between foreground and background works with similarity of texture to create motion. Your eye moves from the texture and the shapes in the wall to the similar texture of the clouds. Even the similar shapes formed between the clouds aid your eye's motion. Although the similarity creates motion to the background, the background is not sharp so your eye will not remain there. Instead, it returns to the wall.

Similarity of texture between the wall and clouds is established by the association in your mind. Puffy clouds are mentally perceived as having a different feel to them than the texture of wispy clouds. The first visual relationship is established. You then perceive the similar shapes and cracks in the wall that are repeated by the clouds and the spaces between them. Look at the top left corner of the wall, then notice the similar shape, tone and texture in the sky. Your eye moves easily from the wall to the sky. As you look at the edges of the wall, notice how the spaces and patterns formed by the clouds are in close proximity to the cracks, resulting in similar shapes in the wall. The small rectangle in the bottom right corner repeats the shape of the wall, and therefore, adds to visual motion around the frame.

SIMILAR COLOR

In painting, the primary colors are yellow, red, and blue. But in photography they are identified as red, green, and blue, and their four opposite, or complementary colors, are cyan, magenta, and yellow. The reason for this difference is found in the construction of film, the process, and the paper used in photography. Transparency, or slide film, is made of three light and color sensitive layers of red, green, and blue. The subject in front of the camera lens is registered on film according to its color. This is defined as an additive process. In color printing, which is called a subtractive process, the complementary colors of cyan, magenta, and yellow are used to subtract color from the primary colors, thereby changing the color of the final print. The colors considered primary, or pure, in photography are different from those used in painting. Regardless of this difference, pure color is seldom seen. A color is affected by the other colors around it.

When you look at a color photograph, your eye sees a primary color and then searches for a complementary color. A balance or harmony is created by the combination of primary and complementary color. Since it is natural for your eye to seek harmony, when a primary color is seen without its complement, your eye automatically produces it.

Quebec, Canada. Leica M-3, 35mm Summicron, Kodacolor II

A couple of shots in this book were taken at this park. Its only attraction was a series of somewhat garish and often lewdly painted cut-outs that people put their heads in to be photographed by friends, family, or lovers. Usually, these cut-outs are found at carnivals, fairs, or landmarks like Niagara Falls, but not in the vast numbers or variety of forms found in this location.

The strange scene, coupled with a strong contrast of hue and similar colors, are the keys to the success of this shot. Contrast of hue (red, green, and blue) is most easily seen in the foreground at the right. Yet, as you look at this area, the contrast continues in the grass, plants, and "Mountie's" pants to the foliage, sky, and the touch of red seen inside the hole for the head. Blue is repeated in the tent, pants, sky, and the indented footstep in the cement. Since yellow is the complement of blue, your eye continues to move to the awning, the key, the frame around the window, the wood slats, and the door. Red is also repeated throughout the photograph. Note the red paint spots on the yellow slats begin this motion of similar objects in red. Red added to yellow produces orange, and that brings the eye to the face on the door and the pots on the far left. Finally, the green in the grass is repeated on the cut-out, the grass behind it, and the trees. These relationships begin a continuous motion that is further enhanced by other groupings of visual elements.

The perception of color depends on the field that it is seen in and its proximity to other colors. Intensity of color can increase or decrease, depending on the contrast between the two colors. For example, a warm color (red, magenta, or yellow) next to a cold color (blue, green, or cyan) will appear closer, while the cold color will appear to recede.

There are seven kinds of color contrast that form the fundamental resource of color design. Goethe, Bezold, Chevreul, and Hölzel have noted the significance of color contrasts. These are:

- Contrast of hue
- Light-Dark contrast
- Cold-Warm contrast
- Complementary contrast
- Simultaneous contrast
- Contrast of saturation
- Contrast of extension

This section can serve only as a small introduction to color, its effects, and the perception of color. The chapter, "Shooting in Color," is an extension of what is introduced here. Color is a subject that is so complex that only a basic overview can be provided, not the comprehensive approach that is covered in entire books.

Jamaica. Nikon F-2, 100mm macro lens, Kodachrome 64

The harmonious tone, proximity, and curved shape of the foliage creates a frame around the center of the shot. Highlights on the telephone wire and the dirt path add to the eye's return to the center.

Contrast of tone produced by the sign situated against the dark background, coupled with a pleasing contrast of hue, creates a strong figure. There is an important contrast of hue with the boy, but the lime green is too garish to create a balance of color.

The warmth of the red in the sign begins a motion to the base of the sign, the pink flowers, and the red stripe on the boy's shirt. Look at the curve of this stripe and the curve in the logo of the sign. This similar shape, in conjunction with the similar color, adds another dimension that brings your eye back to the sign. In fact, the sweep of the tree line in the background is similar to the curve in the logo, reinforcing the relationship of similarity of shape.

SYMMETRY

As you look around the room you are presently in, most, if not all, the shapes that are designed and manmade are symmetrical. The books, windows, tables, doors, and chairs, to list only a few, are all designed with an identical shape and size on either side. Granted there may be objects, like a mirror, that are not symmetrical. The mirror, however, serves as a decorative element that is in contrast to the functional and predictable symmetrical design of the other objects.

As a result, there is a natural inclination for the eye to see a symmetrical element in a photograph as figure. Symmetrical elements and areas that are perceived as more symmetrical than other elements will be grouped as figures within the frame. However, elements can be similar without being symmetrical. If they are seen as both similar and symmetrical, a repetitive grouping creates a visual rhythm and balance.

Symmetry is usually found in design, graphics, and line sketches rather than in photography. The use of similar line or similar edge defines the form. In a photograph, a symmetrical image can be altered in its perception as figure when the characteristics of color, tone, and shape are added. For an element to be grouped and seen as figure, a number of concepts reinforcing the same grouping must be present. Symmetry enhances the possibility of grouping, but in a photograph no one concept should dominate.

Circus World, Florida. Rolleiflex 2¼"-square, 80mm Zeiss Planar lens, Tri-X Pan Professional

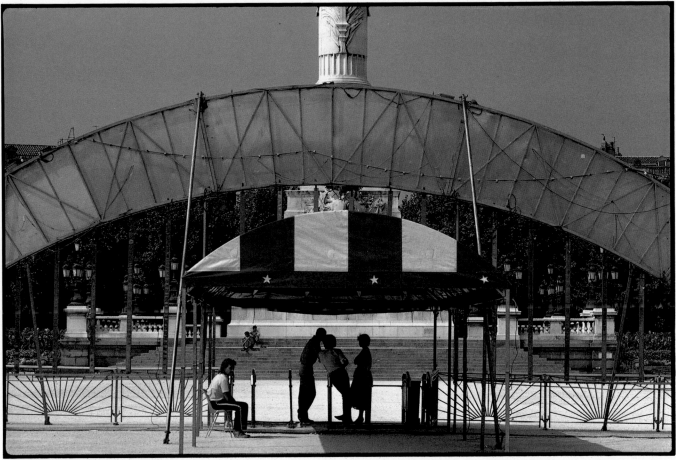

Bordeaux, France. Nikon F-2, 100mm macro lens, Kodachrome 64

◁ Balance is the one word that sums up this symmetrical image. Three trees and their shadows tilt to the left as the clouds move across the frame to the right. A pole on the right above the sign is repeated on the left side of the frame. The two larger trees intersect the type and have clouds directly above them. The lack of contrast and the similar tone of trees, needles, and grass result in a two-dimensional effect. Compression front-to-back creates better proximity and makes grouping of the tree, type, and clouds a stronger relationship. As you look at the tree and the sky on the left side of the frame, you will see that it is slightly dissimilar to the rest of the image. The tree on the left is shorter, does not overlap the type, intersects its own shadow, has a patch of sky above it, and a patch of weeds to its left. This apparent imbalance is necessary to avoid boredom and to stimulate motion. Even these dissimilar qualities are compensated for and answered differently. The shadow may be intersected, but the patch of weeds repeats the shadow's shape. No cloud appears above the sign, but the circle of sky creates its own answer to the tree below it. New relationships are established, and movement is enhanced.

△ As the statue divides the frame in half, identical elements repeated on either side result in a symmetrical and balanced image. Flowers, steps, bannisters, lightposts, and lights appear on both sides and are similar in their placement. Also, the curve of the canopy re-divides the image and sky into a similar size and shape. Even the roofs in the background have been divided into a similar shape and size. The point of the roof (on the right) adds an element of dissimilarity so that the division of space is not monotonous. It is this equal and empty space of the sky that acts as a visual resting place and balance to the busyness below. Additional symmetry is created by the gray beams that support the canopy. Not only are they identical, but the space they divide is similar in size on both sides of the frame.

Look at the beams and compare how they divide the elements in the background. Because they intersect these elements differently, the dissimilarity invites comparison and fosters movement between the two areas. Also, the contrast of the people silhouetted under the canopy against the symmetry of the rest of the frame enhances the perception of people being seen as figure. As you look at these people, you will see the shapes of white space they create against the background are similar.

CONTINUATION

As you drive down the highway you use the broken yellow lines as a guide to stay on the road. Since the lines are similar, have good proximity, and are equally spaced, your mind sees the lines as continuous. The grouping of similar visual elements with the least interruptions allows the mind to see the elements as continuous.

Newspapers, movies, and video games (to name a few) all rely on the mind's ability to group elements and see them as continuous. If you take a magnifying glass and look at a newspaper photograph, you'll see the image is made up of a dot matrix system. Yet, when you look at the image normally, it is seen completely, not as a series of dots. A television screen and video games are made up of numerous lights that are seen in groups to make the image whole. Think of the string of lights on a Christmas tree. When they blink out of sequence, you see them as a group of individual bulbs. Blinking simultaneously, they appear to form a continuous line.

Photographs are sequenced in a gallery so that there is a continuous motion from one image to the next. In this case, your eye moves from one still image to another. Movies employ a continuous series of stills that move at a fast rate of speed. You see the movie as one continuous image. Although an incoherent story line or bad acting can diminish the movement of the picture, poor editing can ruin it. During the editing of a film, all the elements are pulled together into a coherent, complete production. Visually, the editor must be aware of the eye's movement. As the scene progresses, the eye should be in the same general area as the place where the last scene ended. If not, you perceive the movie as jumping around and difficult to watch. A good movie should move from one scene to another in a smooth, continuous motion.

Lugano, Switzerland. Leica M-3, 35mm Summicron lens, Kodacolor 100

Coney Island, New York. Nikon F-2, 100mm macro lens, Kodachrome 64

◁ Simplicity and continuous gentle movement are the two things that initially attract visual interest and then maintain it. The subtlety of tone, color, and texture add the necessary elements to further enhance and complement the simplicity of the image. The eye level angle-of-view provides a perspective that is dynamic and real.

All the rails are similar in shape and size, but the direction of the railings is different. The intersecting and overlapping railings make movement continuous. The lone vertical rail on the right not only answers the verticals on the left, but also serves to slow the eye down so that it doesn't continue off the frame. Similar rectangular shapes formed by the overlapping rails add to the motion, both side-to-side and up-and-down. On the right, the horizontal rectangles, molded by the bars, are similar in appearance to the shapes on the left side of the frame. Visual balance is enhanced by the triangular shapes caused by the railing's division of the frame. There is a similarity of shape throughout the frame. The continuation of line not only fosters motion, but it also divides the frame, creating similar shapes that add more dimension to the simplicity of the shot.

△ This image seems to cause the eye to move more rapidly than the other shot. The difference occurs because of the high contrast and the increase in color and elements. Initially, your eye sees two white boards with the brown one in the center. The light tone of the white makes the brown board come forward while the contrast makes the brown more easily seen. Only the brown and white continue across the frame, the gray slat is interrupted at the bottom of the frame. This interruption, in conjunction with the dark tone of the gray, makes the gray appear to recede. Discontinuation of the gray line as it meets the brown at the bottom of the frame supplies a necessary imbalance. As it serves to slow the eye and end the continuous line of color in the rest of the frame, it still maintains the continuation of line and rectangular shape.

Similar triangular and rectangular shapes add further motion up-and-down and side-to-side. Rectangular shapes are seen in the boards, doors, and bricks. Awareness of the triangular shapes is evident after you see the dominant rectangle. Triangle formation is found in the red strip of bricks on right, white strip next to the red brick as it intersects the panel. The form also occurs atop the yellow door, in the boards above the fifth white slat, and with the top right corner.

The vertical shapes and similar color of the red exposed brick and brown door act as a counterpoint to the strong horizontal movement. The size of the doors is the reverse of what you would expect. What is closer is usually seen as being larger.

Look at the red lines between the bricks. You will see that the lines continue onto the brown louvered door, but not in the bottom 20 percent of the frame. Continuation of line stops in the same area that the gray slat is interrupted. Small things like this will enhance a photograph and make it successful.

CLOSURE

When you see a portrait of someone from the waist up with the elbows cropped out, do you assume that they have no elbows and no bottom half of their body? Of course not; your mind completes the image of the body from memory, and the elbows are seen as complete. There is no reason to expect that the rest of the person does not exist. Because your mind automatically completes (closes) the figure, people who have lost a limb or are affected by physical impediments are shown full length in a photograph in order to define the loss.

You see shapes and lines that are familiar, as complete (closed) rather than incomplete. This is a continuous, automatic, unconscious, and necessary process. Think of how often you see only a portion of an object and "see" it as complete. For example, as you walk down a street, you see half a clock, the front of a cab, the back of a bus; they are familiar shapes so your mind completes them automatically. Imagine how complicated and time consuming life would be if you had to see a whole cab to know what it was.

For lines or shapes to be seen as closed, they must have good proximity, be similar, and form a continuous element. For example, you look from a mountaintop and see a road that winds downward. Periodically, the road is interrupted by trees, yet you will see the line of road as closed (complete)—only if the space between the trees is not too large. Closure of shape and line is another way in which your mind organizes information.

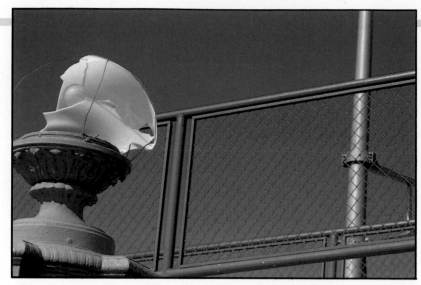

Asbury Park, New Jersey. Nikon F-2, 100mm macro lens, Kodachrome 64

This is a good example of your mind's ability to automatically create closure. When you first look at this shot, you see the lamp as complete and unbroken. Actually, only the bulb and the circular frame of the lamp are completely intact. Because the bulb is smaller, recognizable, and closed, you see it first. Closure is possible because of the similar shape of the bulb and the frame as well as the continuous line of the frame. The relationship that you associate and know between the two elements makes closure possible. Had the bulb been broken, closure would have been difficult if not impossible. Visual interest is created by the reality of the scene in contrast to what your mind originally perceived.

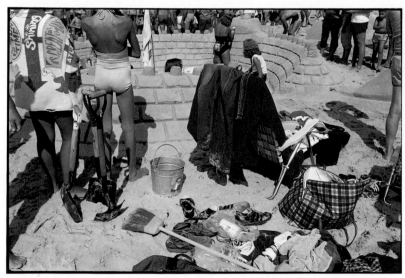

Ipswich, Massachusetts. Leica M-3, 35mm Summicron lens, Kodacolor 100

Closure, or rather the search to create closure, is the key to visual motion in this photograph. At first, you see this scene of an elaborate sand castle, its creators, and a seemingly endless number of observers. As you look closely at the people in the shot, it becomes clear that no one is portrayed in their entirety. Not one person is shown head-to-toe without some portion of their body cropped by another person or the frame of the picture. The people's shadows on the left and the right side of the frame act as the only closed figures. These shadows and the mind's search for, and closure of, cropped people, causes movement. Seeing all the pieces of people allows closure and permits the viewer to see them as whole within the frame. In addition, the two boys in the top left and top right corners are the only people facing the camera. All others are cropped at the waist, seen from the back, or shown in profile.

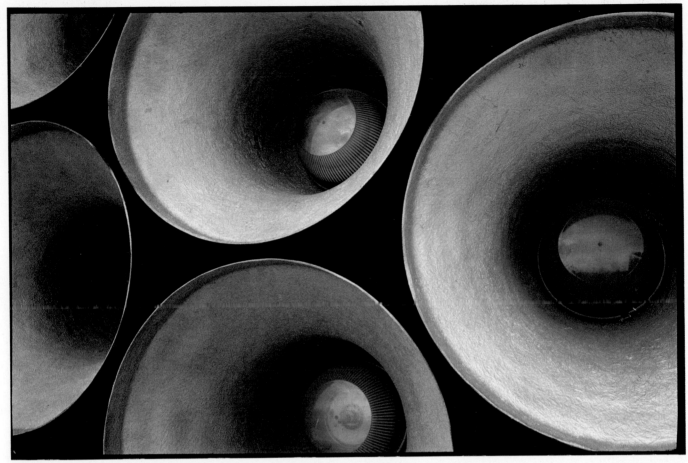

Coney Island, New York. Leica M-3, 35mm Summicron lens, Kodacolor 100

Sometimes the photographer is confronted with a scene, such as this, where one object and one shape is continuously repeated. By shooting at an angle, you decrease the actual repetition of the entire object and increase the visual motion by emphasizing the strength of the shapes. The only complete bulb is the red one on the right. None of the reflectors are shown in their entirety. Because the red bulb is closed, smaller, and warm in color, it is seen as figure. Once that is established in your mind, the similar, continuous shapes of bulbs and reflectors move the eye around the frame. Your eye first sees the bulbs and then moves to the reflectors. Closure of bulbs and reflectors is due to good proximity, similar shape, continuous line, and your memory of how the complete bulb and reflectors look. It is this memory and automatic closure that creates the strength of the frame. Even though the frame inhibits closure, your mind completes it.

Two other aspects contribute to visual movement. First, the space between the reflectors is similar in shape, continuous, and reinforces the circular motion of reflectors and bulbs. If you take the reflectors on the left and the right side and place them together, they form a complete reflector. The same holds true for the top and bottom of the frame. Combining opposite sides of the frame results in a complete reflector, enhancing the perception of closure and how the frame actually works to encourage and inhibit that perception.

FRAME WITHIN A FRAME

By applying similarity of shape in a different way, the photographer can create a "frame within a frame." The phrase describes the effect caused by the continuous use of similar shapes to frame the figure. The technique can enhance the importance, and consequently, the perception of figure. On another level, the technique can be instrumental in creating a good figure/ground flip.

In addition, this specific application of similarity of shape fosters a repetition that initiates movement within the photograph. It may also be used to add other dimensions to enhance the image. The perception of depth may be made more obvious, a person can be aggrandized in portraiture. Some aspects of surrealism or illusion may be evoked by the use of the frame within a frame. The following photographs were chosen to illustrate this concept, but other images throughout the book contain a frame within a frame—if you look for them.

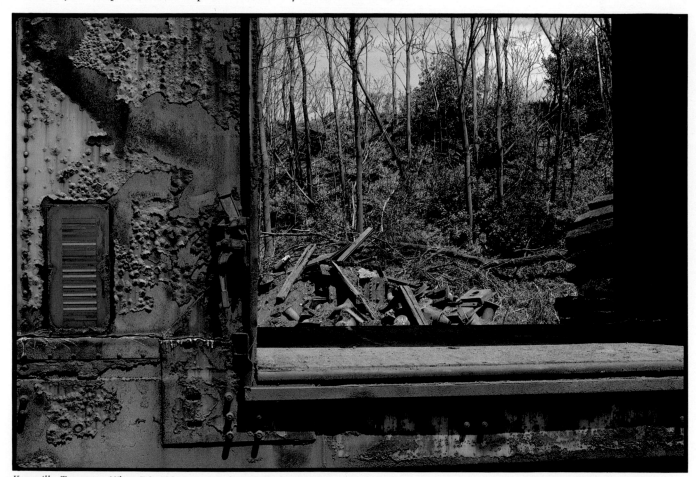

Knoxville, Tennessee. Nikon F-2, 100mm macro lens, Kodachrome 64

The usage of this technique is important here, but it is not the continuous repetition seen in the other example. The frame within a frame is created by the edges and floor of the box car, but front-to-back motion is maintained by the subtle similarities between the two planes. Initially, the lighter tonality of the background and its frame creates a figure/ground flip. Similarity of texture is found in the plates and mottled paint, and the floor of the box car repeats the texture of the scrap metal. Repetition of similar colors in both areas of the frame produces motion. Similar shapes are found in the trees, the logs, and the lines in the car as well as the rectangles that create the framing of both areas. The added quality of the shapes' similar color, as shown in the brown rust and logs, continues the gentle seesaw movement throughout the frame.

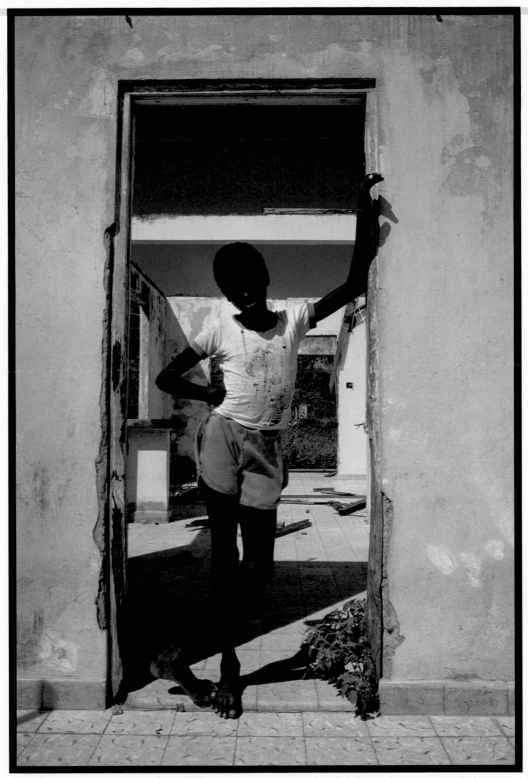

Jamaica. Nikon F-2, 28mm lens, Kodachrome 64

By using rectangular shapes to frame the subject, a more dynamic portrait has been created. Continuous repetition of the rectangular shape leads the eye around the frame and serves to emphasize the visual importance of the subject. The strong contrast of the boy's dark skin against his white shirt, added to the light background, enhances the figure's visual strength.

The rectangular shape of the photograph's frame establishes a shape that is repeated in the tile floor, door frame, door, walls, ceiling beam and the shapes it creates, the door in background, and the shadows on the left side of the frame. The boy's arms form and create triangles that are repeated in the shadows, the line of his hip, space above him, and the crossing of his legs.

SUMMARY

The concepts discussed in this chapter should provide a basic understanding of how the mind organizes information. These are not rules to follow or carry around in your camera bag. However, knowledge and awareness of how the mind groups elements is a valuable tool in the design of a photograph.

For the photographer, this chapter provides a way to look at the pieces of an image that, separately or collectively, make it succeed or fail. To become a better photographer, you must learn from the shots that didn't work. This information can assist in that process. Since one great photograph is the sum of the hundreds and thousands of failures that came before, understanding the reasons why photographs don't work results in the knowledge that will allow you to correct your mistakes and be aware for future shots.

In commercial work, knowledge of these concepts can aid in communication with the client. You can provide explanations as to why a light should be moved forward or a prop should be repositioned. Using terms like proximity and figure/ground flip will only create confusion. But, you can show and explain what is created and reduced by movement of lights and elements. This offers a way to talk to the client about the visual design of the shot, and therefore informs and involves the client in the process of creating the shot.

The photographs used in this chapter were selected because their greatest strength illustrates the concept. In many cases, it was inappropriate to break the images down to all the concepts that made the shot work. Before you look through the rest of the book, go back and look at the examples and identify the additional concepts that enhance the motion of the image. Remember that the main strengths have been covered, but it is the little elements that add to the success or failure of a picture. As you continue through the book, examine the shots thoroughly to train your eye to see why it is or isn't successful.

By itself, this knowledge provides a foundation. Its application throughout the book and, most importantly, by your taking pictures will make it more real and tangible. The chapter that follows, "Look Before You See", will illustrate these concepts, give options on how to use them, and provide ways to expand your vision of the world. The remainder of the book will use examples to illustrate solutions to certain problems, boundaries, and situations. Consequently, captions will address the important design elements and major issues relevant to the sections, not a detailed breakdown of visual concepts.

The following three examples are analyzed by identifying all relevant concepts and the role they play in creating visual motion. Since each topic was covered separately, examining the collective interaction of all the concepts will result in an overall look at how they work together.

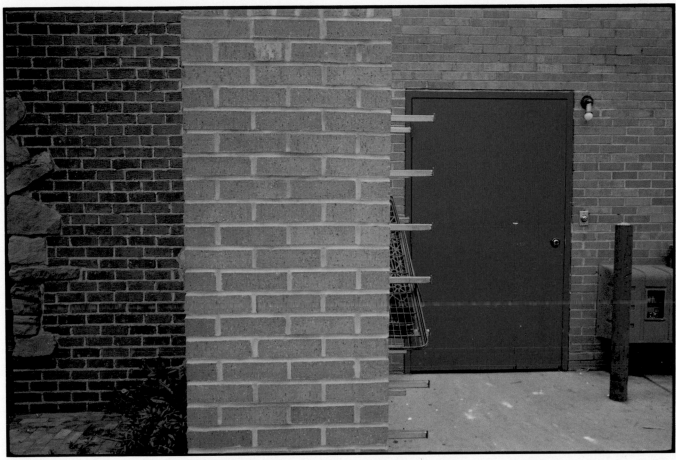

Lansing, Michigan. Leica M-3, 35mm Summicron lens, Kodacolor 100

Figure/Ground Flip: The brick dividing-wall in the center becomes the background as the color, lighter tonalities, and light-to-dark relationships enhance the background now seen as figure.

Proximity: Bricks on both sides of the background facilitate movement front-to-back, up-and-down, and side-to-side. The overlap of bars and rock enhance movement front-to-back.

Similarity of Shape: The shape of a rectangle is repeated in the bricks, metal bars, door, post, and the electrical box. Also, the circular shape of the doorknob, the light, the doorbell, and the post is repeated and answered by the circular shape in the bricks on the left side of the frame.

Similarity of Texture: In addition to the similar texture of the bricks and the concrete, repetition of the smooth texture occurs in the metal rack, the red brackets, the door, the doorknob, the light bulb, and glass in the gray metal.

Similarity of Color: Contrast of hue (red, green, and blue) establishes a strong, harmonious balance. The warmth of the bricks and red rock move forward while the blue and green appear to recede, reinforcing the perception of depth. The complements of all primary colors are present. The blue door is answered by the yellow of the bricks in the center (red plus yellow equals orange). The red rock's complement of cyan is in the electrical box. The green foliage is complemented by the magenta in the bricks at the left.

Closure: The incomplete bricks are seen as closed due to the repetition of complete similar elements within the frame.

Continuation: Both the bricks and the space between them form a continuous straight line that moves across the frame.

Symmetry: A symmetrical and balanced image is created by the similar shape, color, and texture in the center, left, and right side of the frame.

There is a necessary interaction and overlapping in the way these concepts work to create visual motion. As a result, it is the sum of all these grouped relationships and their repetitive use of the same elements to establish new groupings that makes the photograph work.

SUMMARY

Proximity: This photograph creates a humorous association between the words on the sign and the woman behind the sign. Movement is enhanced front-to-back by the pylon under her chin, the Polaroids next to the edge of the castle, the worker's proximity to the pylon, and on the left, the shovel handle with the pylon in the background.

Similarity of Shape: Three shapes are similar and establish relationships that reinforce visual motion. *Rectangle*—Repeated in the sign, wallet in pocket, dustpan on the right side, frame of sculpture, lawn chairs, outlet, and Polaroids. *Circle*—Curve in woman's body, her head, helmets, man sculpting, pylons, tool handles, saw handle, and the top of the pylon. *Triangle*—Support behind the stand, arm on hip, man's legs, bikini top, woman's nose, splayed fingers, pylons, chairs, more pylons, legs in background, handles of tools on left, and shafts of tools on the far right.

Size: Similar size is repeated in the Polaroids, pylons and shovel handles.

Similarity and Proximity: Similar shapes are also emphasized through proximity: sign and woman with triangle shapes; polaroids and the edge of square sculpture; pylon and man in the pit having triangle and circle shapes that are similar; handles on left with the pylon—triangle and pylon; pylon and saw in the foreground.

Texture: Repetition of textures occurs throughout: Most obvious similarity is all the sand; plastic of helmets; wood in tool shafts and wood barriers on right; metal of sign support and tools.

Color: Color is used to "connect" elements in the photograph; warmth of orange and red comes forward; blue jeans lead eye to yellow in the helmets (complement); red bucket in background answered by cyan towel; dark color of sign and pylon against lighter sand makes it stand out more; orange repeated in the sign, pylons, water spritzer on right, tools inside box, more pylons, and trim of boy's bathing suit top left corner.

Continuation: Continuity is maintained through continuous line of frame of sandbox and people walking in background.

Closure: The principle of closure allows the mind to see shape of outlet and frame the sculpture and people, chairs, shovels and saw as complete.

Ipswich, Massachusetts. Leica M-3, 35mm Summicron lens, Kodacolor 100

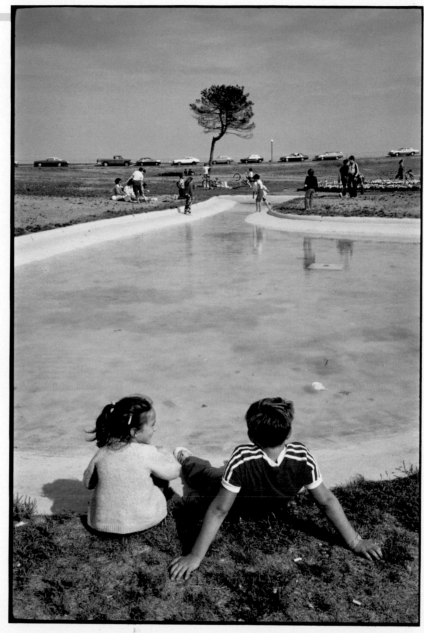

Nantucket, Massachusetts. Leica M-3, 35mm Summicron lens, Kodacolor 100

Figure/Ground Flip: Children initially seen as figure become ground as the stronger shape and the lighter tonality of pool are seen as figure. The warmth of the red t-shirt comes forward, enhancing the initial perception of the child as figure.

Proximity: You group the children in foreground because they overlap each other and the pool. The children by the pool in the background reinforce the relationship between the children and the pool. Proximity of the people with cars, flowers, and trees continue movement front-to-back, and add motion side-to-side seen in foreground. People and cars are also grouped because of the association that people drive cars.

Similarity of Shape: Repetition of shapes reinforces and establishes strong groupings and movement. This balance between foreground and background creates a strong grouping between the two areas.

The shape of a circle and semi-circle can be seen in the children's heads, wrist band, sneaker, hair line, ears, shoulders, and stripes on the shirt, pool, flower, bed, tree, bicycle wheel, car wheels, and light bulb. All people and the cars are separately grouped by their shape. Even the shape of the tree is similar to the lamp in the background.

Similarity and Proximity: Reflections in the pool can be easily grouped with the people in the background.

Proximity & Area/Contrast & Area: Repetition of stripes on the boy's shirt are strong and are answered by the tree, boy's jacket, and flower bed in the background.

Continuation: Again, the stripes of the shirt the boy is wearing are reinforced in importance. Note that the line of cars in background is continuous, but the two cars facing the opposite direction slow this movement. Triangular shapes, first found in the foreground in the girls' arms, boys' arms, and shadows of arms continue to the collar of his shirt, between boy and girl, and in the fork of the tree.

Similarity of Texture: In addition to similar shape of hair on the boy's head and the tree, textures seem similar. The texture of grass is similar in the front and in the back.

Color: A good contrast of hue is repeated at the end of the pool.

Size: Groupings of children in foreground, the people and cars in background are easily established.

Closure: The pool is perceived as complete, but not as much due to proximity and continuation of line as to the experience and the memory of the pool's shape.

LOOK BEFORE YOU SEE

Buffalo, New York. Nikon F-2, 100mm macro lens, Kodachrome 64

*"Shoot however and whatever you want.
Don't listen to anybody else,
just go in the direction you have chosen."*

—*Walker Evans*

Your eye is a muscle that must be developed, disciplined, refined, and then given freedom. The examples and the exercises in this chapter illustrate the questions and the answers a photographer asks himself as he shoots. As a photographer looks through the camera, these questions exist on a conscious or unconscious level. Eventually, an experienced photographer instinctively knows the perfect shot, but that may be the time to move on and try something different.

Many years ago I had the opportunity to spend some time with Walker Evans. After six months of picture-taking, I showed him my work. He told me, "Shoot however and whatever you want. Don't listen to anybody else, just go in the direction you have chosen. The basics are here, but you need to *look before you see*." I was too young at the time to understand the last phrase. Two years later, I began to get a glimmer of what he meant.

The exercises are designed to help you begin to discover your own particular vision. They will not make you see. The ability to see is a vision which is pure and unencumbered by previous knowledge and experience. People who have this ability are the masters of their field. This is not meant to discourage, it is meant to define the process and the goal. Very few masters were child prodigies. They had to start somewhere; I assume they did have to look before they could see.

The exercises have actually been done by me and were used in a photography class. By studying them, you will hopefully gain a basic idea of what is possible. Combined, their purpose is to assist you in looking at the world with an awareness of greater possibilities than you saw before. Be aware that this information is not technical in nature. The results you see will occur over a period of time and may not register on a conscious level.

For maximum benefit, I would suggest doing the exercises yourself. You will learn more by doing them than just by looking at them. Also, they will become more real and tangible when you have done them yourself. Investing a few days of your time and 6–12 rolls of film (either black-and-white or color) will be worthwhile when your photographs begin to more closely resemble what you intended. Since there is no time limit, take your time and think the shots out. Keep in mind that each exercise may not result in a good or great photograph, but learning from your mistakes will make your future photographs better.

Whether you do these exercises or not, use this section to understand what doesn't work in your own photos. Once you are aware of the mistake you made, you will be less likely to repeat it. Personally, I now learn from the photos that aren't successful; the good shots teach me nothing for the future. As I stated earlier, these exercises are done continuously on a conscious or unconscious level every time a photographer picks up a camera.

After years of peering through the viewfinder of a camera, the shape of the frame for all formats and the angle of view of most lenses is engraved in my mind. As I look around a room or walk down a street, I constantly frame images in my mind. This process is continuous, though not necessarily conscious.

To the non-professional, use of the camera is sporadic. There is, however, one portable alternative that will assist you in developing an awareness of the frame. Take one of your rejected slides and remove the film from the mount without ruining the frame. Carry this frame around with you and use it when you have the opportunity to look at a scene. Obviously, you should not use this technique at a job interview or important social engagements. Since the average human being spends about seven years of his or her life waiting (on hold, at the bank, for friends, etc.) utilize the time to see how things look through this frame. This is a simple and extraordinarily effective way to increase your awareness of the frame.

The exercises and techniques presented in this chapter have only one purpose, to illustrate different options and various methods to help you to improve your ability to look at the world with a camera.

A SINGLE SUBJECT

Since there is hardly anything that you will shoot that has not been done before, it will be your way of seeing the subject that will make the difference. The purpose of this section is to illustrate the range of possibilities presented by a single subject. This exercise will provide a way to push yourself to look at the sum and the parts of one subject, and make the most out of what you shoot. As a student and an instructor, I have found this to be one of the most useful and effective exercises in developing one's vision. Remember this is only a starting point, not the solution.

A photographer looks at a single subject. The focus on one subject is repeated not only in this chapter but throughout the book to reinforce each idea. Each section is integrally related to the basic concept of how to see and then place a subject on film as you saw it.

For the professional, this exercise is done every time a camera is picked up. The questions are: "What do I see that makes this special? What can I add to make it more than it appears to be?" The tools include focus, lens, film, angle, distance, filters, and so forth. This does not mean that the questions and solutions are part of a conscious process; repetition makes this possible. At this point, the professional faces the constant challenge to continue to see something special. A photographer must maintain a never-ending fascination with the process and what is in front of the lens. When this ebbs, a photographer must push harder or be satisfied with the prospect of repeating the same type of image over and over again.

The subject used to illustrate this exercise is a structure that was built to cover up extensive construction work in the Olympic Sports Complex. These three photographs were shot with the same focal length lens and represent the essence of this exercise.

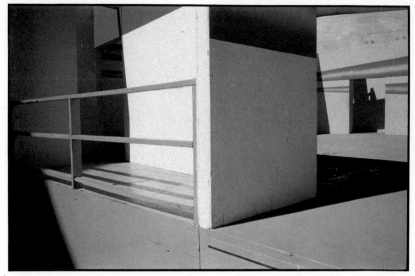

The first thing that strikes the eye is a very strong use of space; similarity in size and shape create good visual motion. These strengths are reduced, however, by the weakness in the use of color and the imbalance of light-to-dark relationships. There is no visual answer to the color on the top and the left of the photograph. The contrast on the left is not balanced by a similar contrast anywhere else in the photograph. Consequently, visual motion in the corner and foreground is made difficult. When I look at this, I feel like I should paint a rectangle of purple on the bottom portion of the frame.

The strengths of this image are found in the use of color and light-to-dark relationships. The power of this image is lessened by the visual division of the frame caused by the vertical line of the wall. The inclusion of the empty gray space in the foreground further reduces the effectiveness of the image. Once your eye moves to the foreground, there is nothing to induce the eye to move to another area. Your eye is not guided, but must jump to the area above or behind the foreground. The division of the frame only serves to keep your eye in the center and bottom of the frame. If you crop the left side (to the vertical line), you will see that the light-to-dark relationships are very similar to those in the third shot.

This shot embodies the strengths of the two earlier shots. It combines the use of space in the first image, and the light-to-dark relationships and color relationships of the second image. The addition of texture by the inclusion of the concrete brings in another dimension to make the photograph more complete. The frame is divided in half just like the second shot, but this division is horizontal.

Montreal, Canada. Leica M-3, 35mm Dual Range Summicron lens, Kodacolor II

On Your Own

Choose one subject to photograph. Your choice of subject should be well considered, something that interests and challenges you, and can hold your interest for 36 frames of film. Do not select something as small as a fly or as big as a city; somewhere in between is perfect. As an instructor, I have seen unbelievable executions of this exercise done with an egg, a telephone, a statue, or a pencil.

Once you have made your selection, take 36 different pictures of the subject. Vary the camera angle, the lens, the distance from the subject and the focus, as you shoot. The first five to ten frames will move quickly, and then you will begin to slow down. Push yourself to shoot until the roll is finished. You will find that the end of the roll will take a lot more time.

After the film is processed, you will be rather amazed at the wide range of images you can get from one subject. Ideally, what you must do every time you shoot is look at each scene in front of your camera as new, and try to see what is different about it.

A CAT'S EYE VIEW

For some unknown reason, many people believe that all photographs should be made while standing in an upright position with the knees locked. Not only will this result in a certain boredom for yourself and your viewers, but it may also limit your ability to visualize a photograph in a particular situation.

Look at the world from various angles. Try climbing a tree, lying on the ground, or kneeling for a fresh perspective. Different angles do provide interesting and different ways of seeing things.

This section has also been illustrated by using only one subject. The purpose is to reinforce the information covered in the previous section. Here, each image is different because of the varying angle-of-view. By changing the angle, you radically alter what has importance in the photograph. The visual motion changes. Every shot you take has to have this kind of thought behind it.

Horizontal framing and a slightly higher angle create a very different image. When I look at this shot, I feel that it tries too hard. It seems as though it tries to be clever, but the area on the right is too dark and uninteresting to make it work. The shadows in the bottom right are strong but not strong enough to carry the entire right side. Also, the same problem of the wired pole and its proximity to the hydrant and yellow pole is repeated. Although the use of the clouds on the left is far better than in the first shot, the orange pylon's intersection of the continuous line of clouds stops visual motion. If you take a piece of paper and crop the yellow beam from the right side, the result is really much better.

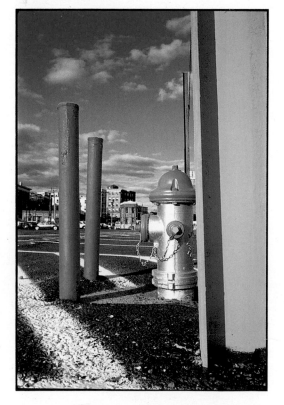

An eye level view of the subject makes the fire plug look animated, creates strong shapes, and a graphic image. Overall, the shot is pretty strong, but as you look at it, you will find two points that impede visual motion. First, the proximity of the pole "growing" out of the hydrant, and the wire attached to it, create such a strong visual tie that your eye has difficulty moving out of the area. The similar shape of this pole and the yellow post on right further keeps your eye in this area. Second, look at the clouds on the left. The sweeping motion of the clouds is strong, but the empty space in-between the clouds is too large. One puffy cloud or a bird or plane is all that's needed to increase the motion in this area.

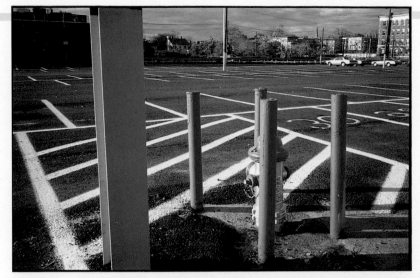

Changing the angle to a higher vantage point further alters the image. An obvious distraction is found in the inclusion of the skyline. Adding another element is often a good idea, but, in this case, it is too light and doesn't relate to the rest of the image. Two other items impede visual movement. The compression of the two posts and the hydrant forms a singular pile of confusion. Each element (as we saw in the earlier shots) can be used because of strength in color and in shape. Here the elements are reduced, and diminished, not utilized. Motion is also impeded by the dead area on the left even though the white lines on the ground connect the space with the rest of the image.

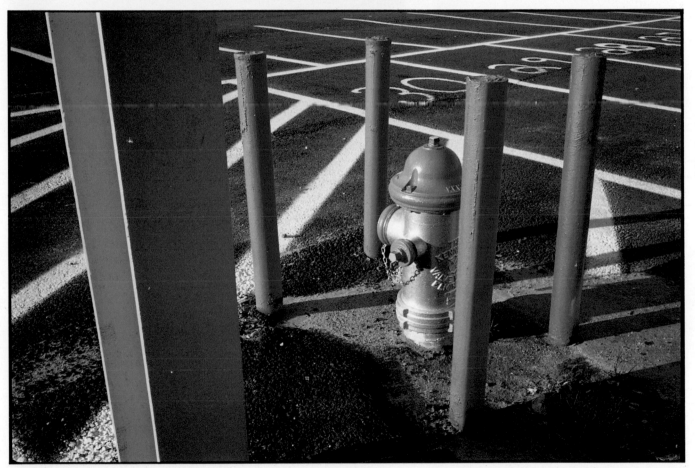

Cambridge, Massachusetts. Leica M-3, 35mm Dual Range Summicron lens, Kodacolor II

This photograph incorporates the visual strengths of the previous images. Moving to the left, raising the viewpoint, pointing the camera down, and moving closer to the subject are the physical changes that made this shot possible. The horizon and distant background have been omitted, and the graphic lines fill the previously empty left side. A change in angle increases the proximity of the lines which allows grouping and creates continuous motion. The numbers for the parking spaces have become strong elements by repeating the circular shape in the post and hydrant. Similarity of shape is, therefore, continuously repeated. Rectangular shapes are found in the shadows, lines, spaces between the lines, post and beams. The shadows form triangles as do the posts' intersection of white lines. Quite simply, this shot works.

On Your Own

As a visual exercise, you should take one roll of film and imagine that you are seeing the world from the perspective of a cat. This does not mean crawling around your house on your stomach taking portraits of your cat! In the event you have an aversion to cats, photograph from a squirrel's eye view.

51

MOVE IN CLOSER

The most common error from an aesthetic viewpoint is positioning yourself too far away from your subject. Keeping a great distance allows too much irrelevant information that detracts from the subject to be included in the frame. As you move closer, you delete the unwanted details. How close you get can vary from hundreds of yards to inches. The result is an image that is easier to read and communicates more effectively.

While on assignment in Houston at the Oil Expo, I looked down from an oil derrick and saw this machine. The colors stood out strongly. After completing the commercial shot I was doing, I shot these photographs. The sequence illustrates how I got to the final image.

The first response I had to the subject is literal and incomplete, but it does show that my eye was drawn to the color and shapes. If you cropped either the top half of bottom half of the shot, you would have a choice of two separate photographs that were unsuccessfully made into one. Either cropped image is better than the full image. As it stands, it does not work because there is too much space in the bottom; the subject is too far away so that the color becomes secondary to the shapes. The framing does not allow the eye to move. Basically, this shot is an "I saw this and here it is!" kind of image. The inclusion of too many details detracted from the image.

Compare this image to the first one. You can see that this image contains only 25 percent of the first one. The transition between these two is quite dramatic. The camera angle is higher, and I have moved in closer. This is a more refined and uncluttered image that utilizes space more efficiently and makes the colors stronger. Details that attracted the eye are emphasized by cropping and moving closer.

Although this is a vast improvement, it is not complete. When I look at this shot, it reminds me of pizza that has been sliced. It looks great, perfectly balanced, but it would look better with a slice or two missing. This shot has that symmetry and balance, but it is so balanced it makes the photograph static. Nothing grabs your eye and creates movement. The photograph is too precise, and this creates boredom. Now, look at the third shot, and see what has been changed.

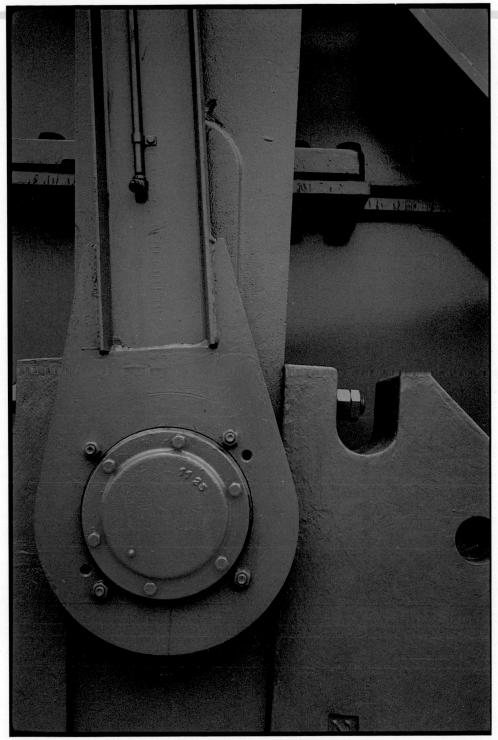

Houston, Texas. Leica M-3, 35mm Dual Range Summicron lens, Kodacolor II

By moving an inch or two closer while tilting the camera down and to the right, I added more space on the bottom. This helps delete the importance of the top shadow and the size of the top right corner. In the second shot, this shadow and corner are so strong that the eye gets stuck there. Also, this cropping creates an imbalance in space between the top and bottom of the frame which helps visual motion. Now the shadow at top is similar in size and in shape to the horizontal bar. The camera tilt to the right and the additional space on the bottom emphasize the vertical bar by creating edge tension. These changes emphasize the circular shape of the orange and blue by adding the two raised dots at the bottom. This allows more space on the right so that the circle is seen as closed.

At first glance, the differences between the second and third shots appear to be minor. Unless a photograph is way off (in this case, the first one), it will always be the little things which will make or break a shot.

On Your Own

I suggest that you take two rolls of film and go out shooting. Each time you decide to take a picture, immediately shoot five more frames of the same subject, moving closer to the subject with each shot. This exercise is the conscious workthrough of what a photographer does unconsciously every time he shoots.

SHOOT LIKE A MACHINE GUN

You must find your own technique to maintain a "creative edge"—that level of awareness that permits you to direct your energy. You will need a method that will help shake out the cobwebs and rejuvenate your creative self. For a change of pace, a writer may read while the athlete may warmup or play another sport. Photographers seem to go on vacation for a change of scene. There are, however, less expensive and less radical solutions such as a museum visit or a trip to the movies. If these don't work, find another way to push open the closed doors in your mind.

A contact sheet offers an opportunity to really see how you think and respond. It represents a visual train of thought. Because the images are unedited and not shown in their final presentation form, a contact sheet provides a clear and honest view of what was seen. Usually, when you see a photograph it is enshrined in a book, a newspaper, a magazine, or placed under glass. Presentation has an effect on how you see the image; a contact sheet never lies.

The following sections of a contact sheet were shot in an hour's walk around the circus. Half the sheet is shown to provide the largest reproduction. Time per shot was kept to a minimum. A number of the frames were bracketed. If you look closely, you will see that it is a way for me to think out what and how I am seeing. By changing the design of the frame, I try to see how the image changes. Also note that the eye seemed to be cued to red.

As you will see, these contacts resemble an artist's sketch pad. Frames 7 through 10 have a similar division of space in the frame, and a humorous viewpoint. The use of space in frames 8 and 9 is so close that only the subject appears to have changed. Color and portions of objects have become the new focus in frames 11 and 12.

Although the first two frames repeat the interest in color and humor, the remainder of the strip changes its direction to color, graphics, and division of the frame. It seems like the last four frames are still trying to successfully complete what was seen in frames 7 through 12. There is the refinement of a number of visual responses. The rearrangement of elements and design is the approach used to merge them together.

The last strip is the summation. In frames 24, 25 and 26, the shot was seen but not completed because it was missing an element. Eventually, this registered and I walked on. On my return, I found the door open as it appears in frames 28 through 30. I returned because I knew something was there, and I knew I had missed it. By moving closer (frame 29 from frame 28), the red on the bottom and the edge on the door have been deleted. The image was simplified. Frame 30 repeats the framing in frame 29 on the bottom and on the right. From the first to last frame, the style of each shot is comprised of strong graphics.

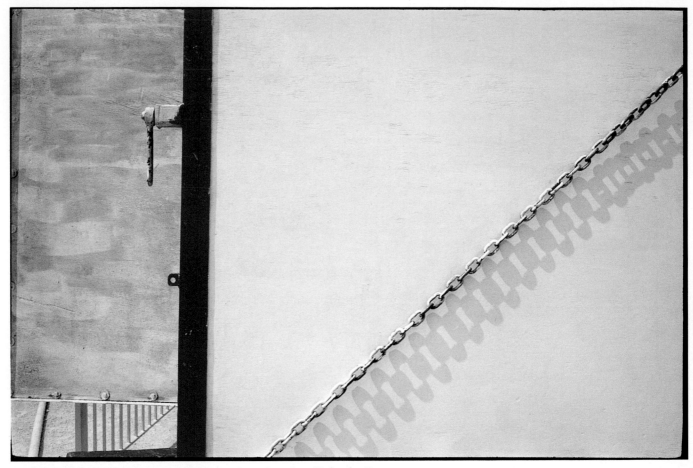

Bordeaux, France. Leica M-3, 35mm Dual Range Summicron lens, Kodacolor II

Surprisingly, this image is the logical conclusion to the ideas sketched throughout the roll. What was lacking in the previous shots has been understood and resolved here. On the other hand, the strengths of color, graphics, space, portions of objects, and pieces in-between two elements have all been incorporated in this shot.

On Your Own

I have found this exercise to be extremely useful in breaking out of a creative rut or slump. The key is to rely on your intuition and first impressions. Go someplace that you have been before, but select a location that is very different from where you would normally shoot. For example, if you are a nature buff, then go and shoot in a city. The idea is to shoot whatever strikes your eye. Do not spend hours composing, changing lenses, and thinking out how the shot looks. Just click the shutter and move on. In one hour, you should shoot 2–4 rolls of film. In this case, a self-imposed time frame is important. It makes it necessary for you to respond to what you see and not think about what you are shooting. I suggest that you shoot negative film because it will be easier to read the results from a contact sheet than it is to evaluate slides seen sequentially on a projector. Proximity, as stated earlier, facilitates learning by comparison.

WAIT FOR THE MOMENT

A photographer must be continuously aware of what is in front of the camera. With this awareness comes a sense of when the shot is right and when it is missing an element that would make it complete. In some instances, the solution could be a change in framing or using a different lens. It may become apparent, however, that there is one element which is missing that would make the shot work. This is a judgment call where you will either be right or wrong. Once this decision has been made, you have to consider the likelihood of this element's arrival in the frame. If you are standing in the desert at dawn, it is unlikely that a car or woman on horseback will cruise into the frame. However, a bird and its shadow may work just as well.

This ability separates the great news, sports, and fashion photographs from the good ones—that split second that allows an eyebrow to raise, a grimace to form, a competitor to fall, or the climax of an event to occur. Fortunately, commercial photographers have motor drives that advance film at about five frames per second. Although this does provide insurance that something will be gotten on film, the photographer still must be aware of and anticipate the action that is about to occur.

At the time I came upon this particular scene it was evident that something was missing. Fortunately, I had the luxury of observing a series of empty buckets move through the frame. To a degree, I could visualize where I wanted to place the buckets in the frame and what color buckets I wanted to include. However, the addition of people added an element that I could not control, and I had to be quick and anticipate what they did. The difference between the two shots is two seconds, but their success is based on my ability to see and respond.

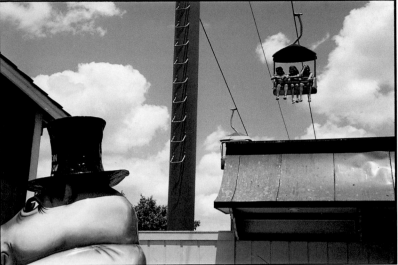

This shot is not bad, but it feels stiff and predictable. The space is too balanced and the dynamic element that the buckets could add is lost. Note how the clouds frame the bucket so that it seems stuck in mid-air. Also, the green bucket's intersection with the roof keeps the eye from moving. As a result, the bottom section (which has too much area) and the purple hippo become too important. In addition to this, the top left corner of the sky lacks an element to balance the buckets on the right. It is close but not close enough to create a dynamic image that moves and adds anticipation.

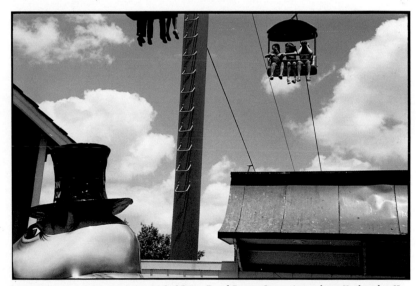

New Orleans, Louisiana. Leica M-3, 35mm Dual Range Summicron lens, Kodacolor II

Besides a two-second time difference that allowed the people's position to change and the entry of the bucket in the top left corner, a change in camera angles also contributed a great deal. By tilting the camera up less of the bottom of the building is included, and there is more space at top for the buckets. The green bucket is no longer visible, and the tilt produces a slant in the orange pole and elongates the cables. Also, note that the hippo becomes an element that contributes rather than weighs down the frame. Compare the position of the bucket which is now riding on the clouds as opposed to the previous shot where the bucket appeared stuck in the clouds. The addition of the bucket in top left corner fills the vacant space that occurred in the first shot. A last item to look at is the hand-arm positions of the girls. Because the positions have changed, the action is more animated and active.

WAIT FOR THE MOMENT

As a photographer, I occasionally do not see a shot, but I sense that something is there—a "sixth sense" about the potential of a situation. In this instance, I walked in a direction without knowing where I was going. Fortunately, I saw the boy running, then the boat, and managed to see the shot. Due to luck and his small size, I was able to outrun him to the boat. With camera pointed down (so as not to attract his attention), I waited and hoped that he would maintain his course and speed. This shot is a combination of intuition, quick reflexes, good physical conditioning, patience, and a healthy amount of luck.

This is a warm-up shot. I knew that it was not the shot, but I just wanted to hear the shutter click. Waiting for the boy to enter the frame gave me the opportunity to see how the shot could fit together, and to consider the placement of the boy within the frame. Look at the second shot. You will notice that this shot is the bottom half of the second one.

Ipswich, Massachusetts. Leica M-3, 35mm Dual Range Summicron lens, Kodacolor II

As the boy began to race through the frame, I raised the camera and adjusted the framing as he ran. Initially, his face was in profile, but he turned his head just before I shot. If his head had not changed direction, the shot would have changed a great deal. The eye would then follow his gaze, and it would have been too strong a movement to the right—your eye would have stayed there.

The cropping of the boat creates motion and tension that is balanced by the boy running.

This shot is definitely a combination of luck and skill. The water receded at the perfect moment, the boy maintained his course, turned his head, and he was carrying a blue shovel. But the skill was to see the shot initially, that "sixth sense", and to know when to click the shutter.

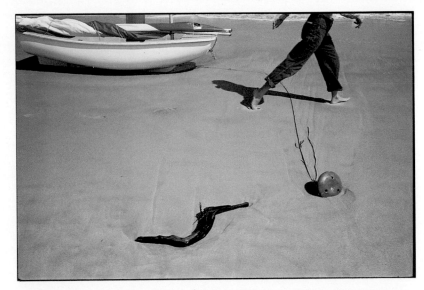

Approximately five seconds elapsed between these two shots. This one is not even close. Both the framing and scale created by a larger and closer subject help to make this image uninspired. The reason this shot is included is to show the difference that five seconds and the inclusion of a different element can make.

WAIT FOR THE LIGHT

There is a magical quality to the light just before and after the sun rises and sets. Shooting at this time of day can certainly add a dramatic quality to a photograph. It does not guarantee that it will make it a terrific image because too many other factors go into the creation of a great shot. Yet, there is really only one moment when the light for a subject is perfect. It is far more likely that you will have to wait for the light to be right than it is that you will initially have the perfect light for your subject when you arrive upon the scene. Usually, a photographer waits for the sun to rise or set a bit, or awaits the movement of clouds blocking the sun.

As you wait for the light to change, it is necessary to watch how the quality of light affects your subject. You may find that what you have waited for is still not the best light. The feathered light of the sun coming from behind a cloud may be far more appropriate than a strong directional light. When you are waiting is not the time to read a book or change the oil in your car. You have to look to see the changes in order to know which is the best light.

This group of images was shot during a five minute period of time. The only major change is the effect the sun creates as it moves in and out of the clouds.

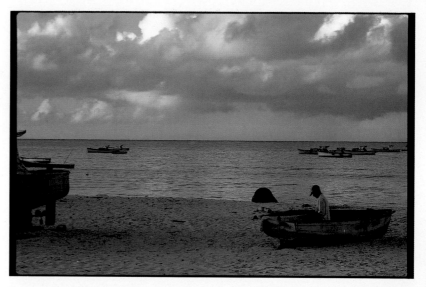

Without the benefit of light, the subject is overwhelmed by the lighter tonality of the water and sky. It seems that there are two separate pictures within the frame. The darkness of the foreground does not permit the viewer to see details, only shapes. Visual movement is difficult.

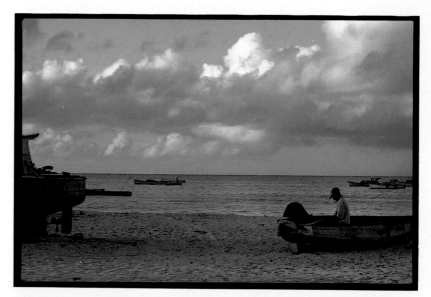

This is a vast improvement over the first example, but it still suffers from many of the same problems. Movement front-to-back is still difficult, but it is aided somewhat by the light defining the shapes in the foreground and their intersection with the shore line. Unfortunately, the foreground is dull, and the light also makes the empty space in the foreground more visible. Even though the light begins to separate figure and ground, and adds a small feeling of texture, it still looks like two separate shots that have been stuck together.

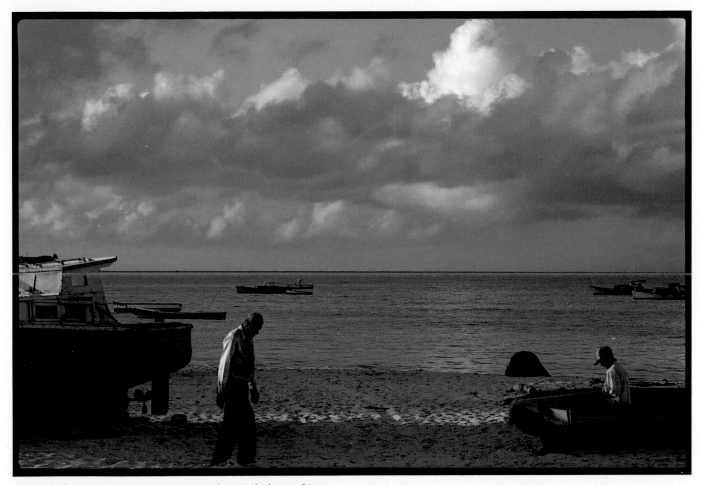

Oisitin, Barbados. Nikon F-2, 100mm macro lens, Kodachrome 64

Directional light adds the dimension of texture, improves movement foreground to background, enhances figure/ground separation, and adds the element of light-to-dark relationships. The tracks in the center of the beach now work to fill the frame. The ray of light moves the eye from the boat, to the man walking, to the man in the boat. The addition of texture draws the eye to the similar texture of the clouds, water, and sand. A five minute wait meant the difference between a boring image and good image.

On Your Own

The next time you are out shooting on one of those days when the sun is constantly going in and out of the clouds, take a series of pictures as the light changes. Shoot when it is overcast, as the sun barely begins to come out a little later, and then with a strong light. By doing this. you will see the process more clearly than examples in any book can show you. The subtleties and the radical effect of the change in light is important for you to understand. For the most dramatic effects, shoot this exercise either in the early morning or late afternoon.

INSTANT RESPONSE

A photographer must always be ready for the unexpected. This section illustrates how to use your intuition as well as how to build up your response time. Remember for the few shots that are successful, there are hundreds upon hundreds that have failed. It is a matter of being in the right place at the right time and being lucky enough to seize the opportunity when it occurs. This section is an extension and variation of the previous one. The basic difference lies in the reliance on intuition and shooting without judgment as to the value of the shot. The examples, as a group, show the unconscious and immediate responses to three different scenes. As I shot, I knew the first two images were uninspiring, but I clicked the shutter anyway.

What you will see is how the use of instant response to a scene or scenes can produce an image. It is also an unusually clear look at how quickly and unconsciously my mind combined a series of unrelated responses to result in one image. The total time for all three shots is no longer than one minute. For me, it is a rare look at the speed and logic of an unconscious process.

As the dog cruised off to my right, I noticed movement to my left. What I saw was the man in the booth turning on the lights. Turning to face this scene, I raised the camera and shot off another frame. Immediately after that, I remember thinking, "Close but no cigar! And that was a wasted shot."

While in Belgium, I came up on a carnival as the crew was preparing for the evening's festivities. After working my way through the fair, I approached the only ride that I hadn't seen. From behind, I heard a dog's footsteps on the wood planking. As the dog bounced toward me—just before I clicked the shutter—I remember thinking, "I like the color of the dog against the color in the floor." Since I usually prefocus my camera and estimate exposure, I was able to turn and shoot. Right after I clicked the shutter, I thought, "I wonder why I shot that. It really was an awful shot."

On Your Own

To quicken your reflexes, I would suggest shooting events that will have large groups of people. County fairs, parades, and amusement parks are good places to encounter large groups of people. One point to keep in mind is that all these people are moving continuously. You should also move constantly looking for shots; if not, your remaining stationary will only make you rather dazzled by the motion of the people.

Belgium. Leica M-3, 35mm Dual Range Summicron lens, Kodacolor II

While I was shooting the second shot, the dog had moved to the position in this picture. The dog's bark attracted my attention. Since I had the camera up to my eye, I just turned, shifted to a vertical framing, and took the shot. The dog then bounced out of view.

Although it is a combination of the first two responses, oddly enough, it seems like I just put them together and changed my framing a bit. I had to shoot the first two in order to see the final shot. It is far more complex and very different than my other photographs. Aside from understanding a bit more about how quickly my mind works, I learned that I can see something complex by breaking it into basics and then reconstructing it.

From a design perspective, the first two shots are so bad that they have nothing to offer, however, the parts of each have value. In sequence, it seems to read: First Shot: I like this subject against this color for the foreground. Second Shot: Here is the background that I want. Third Shot: This is it all put together. The elements that are used in the third photograph appear in the first two photographs. The angle in the yellow boards is identical in the first and third images.

ANIMATE

When you animate an object, you give it a breath of life that it didn't have originally. The object is shown as something more and something different than it really is. Success is predicated on the viewer's ability to see the image and relate it to something familiar. For example, cartoons in print, television, and movies have educated viewers to see the front of a car as a face. The function of the mind is to make this assimilation and to define the unfamiliar by relating it to some kind of familiar form. A shot that animates an object relies on this fact and the design of the image.

Precise design removes details that would detract from the success of the photograph. All tools available to the photographer are used to create this effect. Selection of focus, lens, and filters are decided according to the subject.

There are two possible ways to animate an object. The first option is to photograph an object which is an inanimate representation of something that is living. Mannequins or floats fall into this category. The other way to animate a subject is to take the mundane and portray it in such a way as to make it look alive. The photographer's vision, the use of the frame, and the tools available make the difference. Obviously, it is far more difficult to animate a fire hydrant than a mannequin.

When I was younger, I used to watch cartoons on television. This shot reminds me of those animated houses with windows for eyes and the roof as the top of the head.

What is strikingly different about this image is that the building in the background is out of focus. The successful figure/ground flip, the lack of details, contrast, and selective focus emphasize the shapes. The bars in the roof act as a background to the house, but the repetition of similar shapes (triangles and rectangles), frame within a frame, and the similar shape of the roof to the building reinforce the viewer's image of the building as figure and animated. Also note that the continuation of line in the roof keeps the eye moving in the frame.

On Your Own

The key to this exercise is not the subject itself but rather how you portray it. Cars, buses, trains, and mannequins, for example, are all obvious choices. Shoot an entire roll of animated images. Because you will be focusing your attention on the one type of image and effect, the shooting will take time and patience. However, the goal is to train your eye to see more and in a different way. Although more frustrating than many of the other exercises in this section, it is a valuable option.

Den Hague, Holland. Nikon F-2, 100mm macro lens, Kodachrome 64

New York, New York. Nikon F-2, 100mm macro lens, Kodachrome 64

This subject was extremely easy to animate. As you can see, this Macy's float construction is extremely realistic. Notice how much attention was paid to the details, the tilt of the horse's head, and the rise of the hooves on the left. A number of elements assist in making this perception of animation successful. By looking up and including the hooves on the left, it gives a real perspective on how you would see horses. A strong quality of light emphasizes the shape of the subject. Selective focus and contrast add to the good figure/ground separation. The eye is drawn to the horse's head by the framing. Look at how much edge tension is created by the near intersection of the horse on the top and right corner of the frame. Including the hooves on the left acts as a balance to the head. As good as the float's construction is, it is the way it is seen, framed, and rendered that creates the animation.

MOTION

Between the high shutter speeds on a camera and the use of electronic flash, the motion of moving objects can be effectively frozen. However, the use of these tools is determined by the effect that you want in the image. No written rule says everything must be sharp with no sign of motion. A blur of movement can give a sense of power, mood, speed, drama, wonder, or unreality. The most continuous and readily available source for seeing how motion is rendered is the sports and news photography you find in magazines and newspapers. This usage is as selective as framing and lens choice.

Visually, motion adds another dimension to a photograph. Motion can separate figure and ground, create visual motion through creating similar shapes, continuation, and closure. It is a visual tool that should be understood and used as selectively as any other tool.

Hoboken, New Jersey. Nikon F-2, 28mm lens, Kodachrome 25

From the technical side, this shot was achieved by hand-holding the camera for 30 seconds to one minute and then tripping a small electronic flash while the shutter was still open. The use of the flash offsets the slow shutter speed. Flash was held at a 45 degree angle to the subject, therefore reducing glare and emphasizing texture. The headlights of a truck in the background illuminated the tree and background.

As you look at the image, you will find that only the rope, the center of the tree, and the blue board are sharp. By blurring the color and the image, a feeling of electricity and mystery is created. Visually, your eye moves to and from the tree to the blue board and back again. The lines in the blue area are repeated in the blurred lines of the background. The blue area also acts as a resting place for your eye.

66

Long Island, New York. Nikon F-2, 28mm lens, Kodachrome 25

Approximately half of this photograph is in motion. The only non-moving objects are the road, the sign, the trees, the poles, and the wires. A time exposure at sunset on a busy road created the movement of the clouds and the blur of head and tail lights. The continuous, similar shapes of the lights are repeated in the road and the clouds. Stationary objects act as a balance to the continuous motion. The sign on the right (lit by my car headlight) acts as a barrier to stop the eye from traveling off the edge of the frame. The dark tonality of the bottom portion of the picture acts as an anchor to balance the light tonality of the sky. Without the blur of motion, this would be an ordinary shot of a road at dusk.

On Your Own

Since the rendering of motion is a tool that is used selectively, experience and judgement gained through experimentation will allow the photographer to make a decision. Application of long time-exposures (with or without a flash) are not the only options available. For your own comparison, select scenes in which you have a choice on how motion can be portrayed. Photograph these scenes with shutter speeds that range from ⅛ to ¹⁄₂₅₀ of a second. Possible options include: busy intersections, marathons, bike races, and other sporting events that you know well. First, you must see for yourself the effects that can be created before you can make an informed decision.

ABSTRACT

An abstract image, by its definition, is not an actual (recognizable) representation of a subject. The photographer focuses on a portion of the subject by using a telephoto lens or moving very close to the subject. Since there is no one point of interest (a recognizable subject) to save it, a precise sense of design is necessary to make a good photograph. Form is primary; content is irrelevant.

For the photographer, this offers another way of seeing the world with a camera. There can be a conflict inherent in this type of work because of the nature of the medium. Usually a camera records life in realistic form. However, the nature of the medium requires that you translate a three-dimensional subject onto a two-dimensional plane. A photograph is always a translation of reality, and it is only representational.

For the viewer, the first question may be, "What is this? No, don't tell me." After trying to identify the subject of the photograph, they may say "What is it?" The search to define something in terms of what is familiar is a natural function of how the mind organizes information. The viewer expects to see something real and recognizable from a camera. This can work either for or against the image, depending on the viewer. For those who can go beyond defining the image in terms of the original subject, it can be enticing, and just another element to add interest. However, some people don't like what they don't know. This reaction is very similar to people's reactions to optical illusions. There are those that are intrigued and challenged. Others are absolutely enraged because it plays with their perception of how things should be. They don't understand what has happened to their reality. Since the viewer's perception is personal, the responsibility of the photographer is to facilitate visual motion within the frame and communicate in a coherent way—no matter what the subject of the photograph may be.

New York, New York. Nikon F-2, 100mm macro lens, Kodachrome 64

When my work is described as having a painterly quality, it means that I have incorporated the qualities of another, more demanding art form. The image transcends its medium and becomes something more to the viewer.

This image, somewhat reminiscent to Picasso in style, is a photograph of the shadows of a phone booth (black areas) as they are cast upon a red wall. An unusual design of the phone booth combined with harsh light and the compression caused by the use of a telephoto lens, resulted in this "two-eyed face" in profile.

Visual movement is facilitated by the repetition of similar shapes seen in the circles of the eyes, curve in the chin, lips, neck, thin gray metal strips, shadows above the head and on the right side of the frame. Triangular shapes are repeated in the point of the head, lips, nose, overlapping of the large gray strip against the background, shadows above the head, points on the thin metal strips, and on the far right side of the frame. The last area listed is seen as curved and triangular in shape. Strong light-to-dark relationships and the repetition of shape combine to form a strong graphic image.

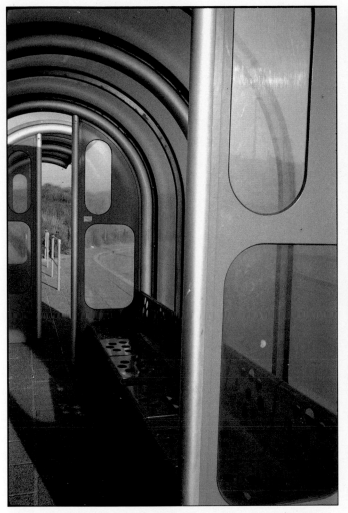 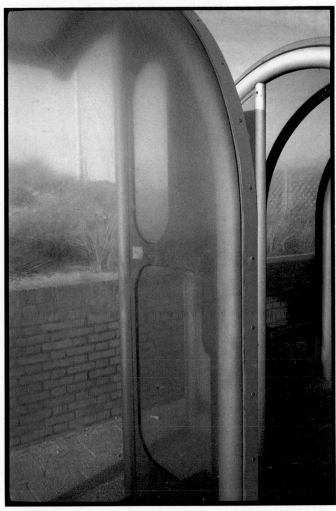

Schvenigen, Holland. Leica M-3, 35mm Dual Range Summicron lens, Kodacolor II

This shot is unsuccessful for a variety of reasons. Diminishing perspective leads the eye through the bus stops, but there is nothing at the end of this tunnel that makes the trip worthwhile. In addition to their lack of visual payoff, the yellow poles are distracting and serve no purpose. Division of space, by the edge of the door in the foreground, is a good idea, but here it is only overbearing and inhibits visual motion. Also, the brightness of the steel edge is so strong that you must force your eye to see the rest of the shot. The image is diluted by an excess of information, bad division of space, and the excessive inclusion of colors (red bench and yellow poles) that inhibit the visual movement.

On Your Own

Take one roll of film and shoot 36 exposures of different abstractions. When you see a subject that attracts your eye, use the camera to look at and isolate the parts. It is form that is primary, not content. This exercise will take time to execute and requires persistence. The result and strength that it provides is to focus your vision solely on design.

Visual strengths of the first shot have been reorganized within the frame and result in a surreal image rather than a literal translation of the scene. Originally, the bright edge of the door inhibited motion. Here, it creates a continuous fluid movement from foreground to background due to the repetition of the curved shapes, and its darker tonality. Although the concept of looking through the plexiglass was unsuccessful in the previous example, it is now used as a primary visual element. Now, it is integrated into the shot by adding depth, muted tonalities, warm pastel colors that answer the red of the bench and the interior of the other bus stop. The light tone of the background attracts the eye and permits movement from the continuous structures to the background. A single white pole on the left is similar in shape to the frames in the bus stops, and it offers another way to return to the foreground.

A literal translation of the scene has now taken on a surreal quality. By focusing on pieces of the whole structure, it combines with the fluid motion, diffused tonalities and muted colors to create an "other world" effect.

SHOOTING IN BLACK-AND-WHITE

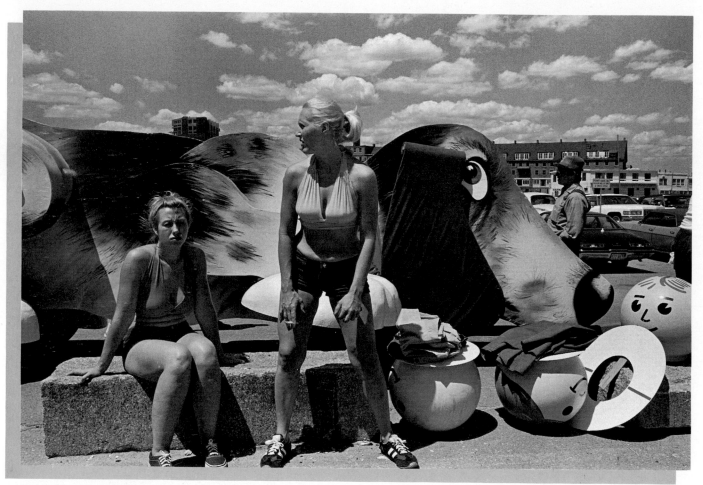

Boston, Massachusetts. Leica M-3, 35mm Summicron lens, Tri-X

"The craft of photography is represented by, and visualized in, the beauty of a good black-and-white print, a translation of the world around us into shades of gray."

A good black-and-white image is something very special. It doesn't strike the same nerve or evoke the same response as a color image, however, beauty, power, and emotion are still evident. The world is seen in a totally different interpretation. By virtue of the image being a translation that lacks the reality of color, it generates more of an intellectual response. The craft of photography is represented by, and visualized in, the beauty of a good black-and-white print, a translation of the world around us into shades of gray.

An understanding of the potential, the controls, and the limitations in the black-and-white process is a preliminary to making a strong color photograph. Knowing the wide variety of controls available within the black-and-white process—from exposure of film to the final print—provides a context in which to view the very limited options available in color.

From a design perspective, this large system of controls offers numerous ways to alter and enhance the final print. Each decision made has an effect on the final image. As a result, each step of the process needs to be understood and thought out before a decision can be made.

FILM PROCESSING

Three controls—filters used during film exposure, the type of film, and the method of development—can have the most radical effects on the final image.

Filters: The choice of filter will affect how bright or dark colors will be seen by the film. Although the film is black-and-white, you are still shooting a color scene. A red filter will create contrast and result in red being rendered as a lighter gray while blue and green will look darker. Yellow, red, and polarizing filters are the most commonly used.

Film: Each film produces a different size grain. The lower the ASA, the finer the grain. Although this is also true for color films, the choice of developer further alters the size and the shape of grain in black-and-white film.

Film and Developer: Another important decision is the exposure/film/developer combination that is used. Numerous choices are available, and they have different effects. For example, Kodak's Tri-X film developed in Kodak D-76 will produce sharp grain and contrasty tonality. Edwal F-G7 has a softer grain and wider tonal range. Acufine, however, produces sharper grain, larger grain, and contrasty tone. A decision must be made before film is exposed as to what the final image should look like in order to best utilize these controls.

PRINT PROCESSING

Two of the most important controls are the choice of printing paper and paper developer.

Paper: Each brand of fiber-based paper has different characteristics. Color and contrast are the two considerations, but even these qualities can be altered through the choice of developer and toning. The inherent characteristics do offer limitations which, though expandable, still have to be worked within: Kodak Polycontrast F paper has green black, low contrast properties. Agfa Portriga is very green black with medium contrast while Agfa Brovira is reddish black with high contrast properties.

Paper Developer: Due to black-and-white film's wide sensitivity and latitude, the range of tonalities offered by lighting—either high or low contrast—can maintain detail, tone, and texture. Selection of exposure in both camera and enlarger and alterations in development of the film makes this possible. Usually one film and system is preferred, it makes life simpler because the results are more predictable.

Since all these controls are available, it might seem logical to conclude that knowledge and experience are the keys to a good black-and-white photograph. Unfortunately, the real key is to develop, to train, and to refine one's vision—to see in shades of gray rather than color. It is a completely different way of seeing that comes with time and experience. Knowing and using all the controls, tools, and limitations of the process would be worthless if the eye lacks the vision to see the subject in terms of its translation into black and white.

OVERCAST LIGHT

The range of tones, from black to white, on an overcast day is seen as being flat or not having a strong range and contrast. Within the process, a number of controls are available to build or to enhance the contrast that is not originally in the scene. Through the expansion of tonal range, you compensate for the low-contrast, passive quality of light on an overcast day.

Since light-to-dark relationships are less strongly defined, the limitations created by the flat lighting must be understood and worked within. This is not meant to imply that flat lighting offers very few possibilities with black-and-white film. If the inherent contrast of the subject can't be increased through exposure and development, then the focus becomes the subtle relationships of the mid-tones. Extra attention and thought are necessary to evaluate how the subject will be rendered within the limitation imposed by a lack of contrast. The strength of the photograph may not be in subtle tonal relationships that are present. This is a judgment that is honed and refined over time.

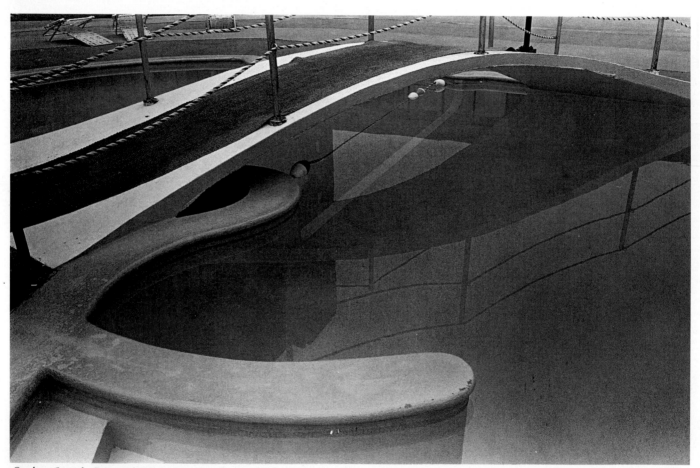

Quebec, Canada. Leica M-3, 35mm Summicron Lens, Tri-X

Since frequent travel and an endless stream of hotel rooms have been a constant in my life, I try to make the time to satisfy my curiosity about my temporary home and environment by walking around in search of photographs. This image, from the swimming pool at a Holiday Inn in Quebec City, came from a quick walk between thunderstorms.

A silence and tranquility is created by the flat light, the smooth sheen of the water, and the dominance of mid-to-light shades of gray. The strong, but smooth and continuous motion across the frame of the walkway and its shadow, is supported and balanced by the similar curves in the edge of the pool, the cement railing of the steps, and the rope railing above. A slightly darker and higher contrast in the mat on the walkway is balanced at either end by the dark area beneath and the dark post above. On the bottom of the pool, the painted line, with the rope and buoys above, create a visual link between foreground and background.

In the midst of a day filled with burning rubber, grease, and dust, I came across this abstract scene on the rear window of a car at a funny-car rally. Since I have spent many years shooting these events, an image like this stands out because of its contrast to the area in which I am shooting.

The image is dominated by the mid-to-light gray tones created by the clouds of an overcast day. A necessary contrast and balance is provided by the black paper strips on the windshield and the trees on the left. The edges of the window are a necessary frame that separates and defines its space and the sky. As the tones in the roof blend into the sky, the light-to-dark relationships of similar tones and textures of reflections and sky above, add another element of balance. Because of this similarity in tone, texture, and shape, as well as the blending of the roof into the sky, the window frame's line is increasingly important.

Epping, New Hampshire. Canon F-1, 100mm lens, Tri-X

Alligator Alley, Florida. Leica M-3, 35mm Summicron lens, Tri-X

With a camera in my hand, a feeling of being invincible seems to filter over me; normal fears seem to fade away. For this shot, I locked both legs and one arm over a railing and hung over this pool of alligators. After a half-hour and ten slices of bread (at a nickel a slice) to guide the alligators into position, I got this shot. When I was done, I realized that perhaps this was not a particularly safety-oriented approach, but I did get the shot. An unusual perspective, with the continuous overlapping and overflow of these "friendly little creatures" makes this image more dynamic. The comparatively empty area of water, with partially submerged swimmers, acts as a necessary balance to the frenzy on the platform. Proximity of shadows cast from the overhanging of the alligators' feet, and the alligator half under the platform adds to the visual motion between these two areas, already established by similarity.

The strength of the scene doesn't require the contrast created by sunlight. A sufficient contrast in tone, coupled with the contrast between the two worlds above and below, is all that is necessary. Strong visual motion between these areas—enhanced by the tilt of the platform, the direction of swimmers, and the curve of tails and heads above—is countered by the different angle of the alligators in the center and the top left corner of the platform.

73

France. Leica M-3, 35mm Summicron lens, Tri-X

The inherent contrast of the scene (dark leaves and tree trunks against the lighter wall and sidewalk) is balanced by the similar light-to-dark relationships (in the wall and sidewalk) to create a rhythmic visual motion. Underexposure of the film eliminates most of the detail in the leaves which are now seen more strongly as shapes. As a result, these shapes are seen as a continuous line across the frame. A similar contrast and pattern is repeated on the streaked wall. The small, dark tree trunks create balance by connecting the darkness above with the lighter tone of the sand and the fallen leaves below. Although the scene is contrasty, the light is not. The texture is rendered clearly, but muted. Essentially, the scene is a study in contrast and balance.

CONTRASTY LIGHT

Contrasty light requires a different approach. Film latitude and the controls available in the process provide a means of maintaining tone, texture, and detail in highlights and shadows. The photographer's judgment of how the scene should look in the final print determines exposure of the film. During the day, the highest contrast created by the sun occurs in early morning and late afternoon. An even greater contrast range is created by the uneven brightness and the distance between the lights that illuminate our world at night. Electronic flash scenes, beach scenes, and snow scenes are high-contrast situations. Although we usually see it as being harsher, the sun at midday is actually a flatter light than earlier or later in the day.

Directional light creates contrast. Direct sunlight and electronic flash not only create an effect on their own, but they also effect a subject by directing visual movement. An awareness of light and the direction it has is necessary. As light increases the brightness of the areas it illuminates, light creates shadows that have size, space, form, and shape. Light-to-dark relationships, as well as texture, are enhanced by the contrast of light. This same contrast more sharply defines the edges of shapes and highlights the subject by separating it from the background.

A backlit situation that results in silhouettes is one of the most dramatic in its effect. Even though the film and developer offer great control, a loss of detail occurs in either the shadow or the highlight area. The dramatic effect is due to the details that are omitted. When exposure is made for the highlights in the scene, the subject will be seen in outline with strongly defined shape and form. This is due to the lack of detail and the edges being sharply defined by contrast.

Whether it creates a silhouette or illuminates the side of a subject or scene, directional light has an active quality attributed to it. It defines and creates motion on its own and by its effect.

Night photography presents a number of elements and problems that are not encountered in daylight. A far greater contrast range is possible because of multiple light sources and limited brilliance. Lens flare is more likely to occur while exposure time is measured in multiple seconds and minutes. The level of light is so low in the shadows that most light meters are rendered useless. Exposure is often guessed, bracketed, and estimated with experience. Difficulty in focusing is also compensated for and insured by the use of a small f-stop. Fortunately, the wide latitude of the film and special film developers for high contrast situations make it possible to hold detail in both shadows and highlights. This combination also makes the reduction of exposure time possible by pushing the ASA/ISO of the film to 1600 without serious grain increase.

Seasonal temperature and humidity changes cause radical changes in the effects created by the light. In summer, the increase in dust pollution and heat combine with light to create a harsh quality. An increase in humidity adds to the other elements to create a strong diffusion of light. Unlike the harshness that increases with the temperature in summer, light in winter increases clarity and crispness of definition as the temperature decreases. Contrast is not increased, only the definition of edge, texture, and shape are seen more clearly. Increased humidity in winter diffuses light, but the low temperature adds a clarity in definition.

In northern climates, the coldness of winter and arrival of snow create problems for the airports. Steam is pumped under areas of the runway and docking areas to melt the ice. For this shot, a spotlight used by workmen acted as a backlight for the steam that was expelled from a vent. A huge snowbank provided me with an eye-level view of the top of the retaining wall that surrounded the runway. The combination of a strong continuous wind with a 30 sec. to 1½ minute exposure resulted in the blur that creates the wispy tonalities.

Usually, this kind of lighting results in some loss of detail in either the highlights or the shadows. The multiple light sources at night provided enough light to fill in the darkness of the wall. As the dominant backlight sharply defines the top edge of the wall, the strong line is repeated vertically on the wall. Wispy tones of the steam act as a contrast and balance to the sharp edges, the lines, and the stones in the wall. The texture of the stones is similar to the steam above due to the sub-zero temperatures.

Boston, Massachusetts. Mamiya C220, 2¼"-square, 80mm lens, Tri-X Pan Professional

This shot of the plastic cover of an illuminated fluorescent light graphically illustrates the use of controls and film latitude available in black-and-white. Everything from the detail in the shadows to the texture of the white plastic is rendered clearly and without loss of definition.

Strong diagonals create and maintain a continuous line of motion. While the black spaces between the squares direct motion one way, the similar size and shape of squares adds motion in a contrasting direction. Repetition and overlapping of similar shapes—rectangle, triangle, and square—create and reform these same shapes. In this frame within a frame, texture is a constant that provides another element of grouping and motion. The strong light-to-dark relationships due to contrast from the light source provide a balance and a visual rhythm.

Boston, Massachusetts. Mamiya C220, 2¼"-square, 80mm lens, Tri-X Pan Professional

Boston, Massachusetts. Mamiya C220, 2¼"-square, 80mm lens, Tri-X Pan Professional

Although the controls within the process offer a solution to the effects of harsh light, the range in this scene was so great that maintaining all detail was impossible. The shadow detail was sacrificed because the brilliance of the row of lights would have increased to the point of visual dominance of the image. Even with this in mind, a moderate *f*-stop with a seven minute exposure was necessary to record this scene.

As the low level of clouds from an imminent snowstorm are lit by the city below, humidity diffuses the light on the buildings. The extremely low temperature and the uneven balance of light create the contrast and clarity seen in the railroad station. This difference in clarity contrasts and combines with the blending of tone so that they continuously balance each other.

A continuous sweep of line that begins with the crack in the cement in the foreground to the roof and tracks is opposed by the vertical buildings and support beams on the platform. Other elements, like the lights, the beams, and the triangular patterns, add the diminishing perspective that leads the eye front-to-back. The similar horizontal light-to-dark relationships at the end of the track and the lights of the building beyond add to the balance.

BURNING AND DODGING

Of all the controls available in the printing process, the ability to selectively lighten (dodge) or darken (burn) areas in the print is the most important. Application of either technique occurs during the exposure of the print. Alteration of tone in any area of the image has an effect on how the total image is perceived. A great deal of thought and attention must be directed to the image before anything is changed in the printing. The evaluation begins by assessing the primary strength and motion of the shot. Does the subject need to be lighter to stand out more, or do areas surrounding it need to be darker instead? Is the balance of light-to-dark relationships in need of enhancement by increasing or decreasing the original value of tonalities?

Each area must be evaluated as a separate entity, and then, as part of the whole picture. Although this process is selectively applied, each area must be examined and evaluated as to how they work together to form the whole image. Judgments and decisions made during this part of the printing process will enhance or reduce the visual relationships that create and direct motion within the frame. How little or much has been changed in printing is not relevant to the viewer. Only the final result that is before them is considered, not the changes you have made to enhance the movement and impact of the photograph.

In the black-and-white print, excessive alteration in one area will result in a muddy tonality. This area, whether a highlight or a shadow, can be either detailed or muddy depending on the printer's knowledge and experimentation. Keep in mind that the condenser enlarger, which is most commonly used for printing black-and-white, tends to distribute light unevenly. Edges of the image receive less light than the center. As a result, these areas should also be burned in to balance out the uneven distribution of light.

In addition to burning and dodging, highlights in the print can be further altered while it is being developed. By removing the print approximately one minute after being placed in the developer, highlights can be darkened by the selective application of hot air (from your lungs) or warm developer with a Q-tip. Heat will accelerate the development of the print in the selected area. The print is then re-immersed in the developer and further heat can be added later if necessary. It is an additional way to enhance the effect that burning has on a specific area.

The following photograph shows the evolution from rough print to final print. A tracing on the back of the print indicates the changes I made during printing and act as a guide for me to use when the photograph is reprinted in the future. The print has been very heavily burned and dodged. The actual change in tonality averages about 7 percent from its original exposure. It is the separate and subtle alterations of tone and light-to-dark relationships in each area that affect the dynamism of the whole photograph.

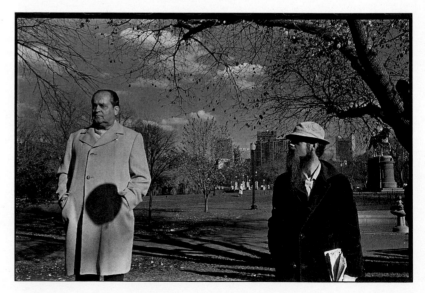

The strength of this shot lies in its incongruity and the questions that it asks. What is going on? Who are these people? Is he really tall or is he standing on something? What is that dark circle on his coat? With this in mind, I made an evaluation as to how I could enhance the incongruity and balance of the image in the printing process.

This outlines all areas that have been altered and the amount of exposure that was applied.
B = burning in (darken) D = dodging (lighten) HA = hot air (accelerate and darken highlights)

This is similar to the area in the center of the picture. Untouched, the man and the white coat do not stand out particularly well from the background. Darkening this section increases contrast between the two areas and the man becomes lighter by comparison.

Although the two men are already seen as the subject, making the area between them darker makes the men seem lighter. The darker background seems to recede, so the tonality of the men seems lighter and moves forward visually.

Making this area lighter increases the contrast of the hat. It also acts as a tonal balance and complement to the man on the left.

These areas have shape but the addition of detail, by dodging, makes them more interesting and less dominant than being seen as a block of space.

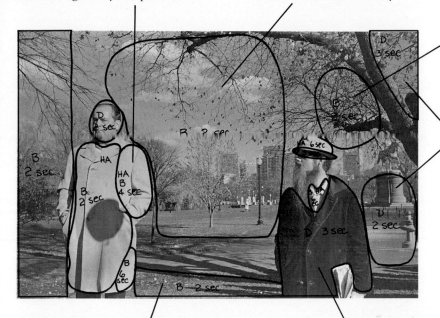

The leaves on the bottom part of the shot are too bright and contrasty. Darkening this area is necessary to reduce its visual importance and place the focus on the men.

Without dodging, this heavy area creates an imbalance in the light-to-dark relationships of the shot. The black coat acts as a balance, so lightening the area to the right will not detract from the interaction between the two men.

Final print

TONING

Unlike the other controls available in the process, toning alters the entire print (on fiber-based paper) by the reduction or addition of color. All shades of gray are affected by this process. Contrast and light-to-dark relationships are magnified by the increased separation of tone and/or the addition of color. The application of this tool, due to the effects created, should be given careful thought and consideration beforehand.

All black-and-white papers have an inherent color cast. Some are more subtle than others, but the color is there nevertheless. Polycontrast F and Portriga are greenish with the former having far less color cast. Brovira has a reddish-brown color. When the finished print is immersed in a toner, the inherent color is either reduced or replaced by the color of the toner. Due to the different effects that are created, toners can be divided into two categories.

Selenium toner (the more commonly used) and gold chloride reduce the original color cast to a more neutral color. As color is deleted (subtracted), the toner not only adds a richness and enhances separation of tones, but acts as a preservative. The effects are subtle, not radical, as seen in the next group. Since these toners have a preservative nature and they are absorbed by the print, this process makes the image archival. It increases its

protection from the deterioration due to acid in the fixer and exposure to light. Unless the removal of color is a desired result, most prints benefit from the richness and separation that these toners create.

Some toners (like sepia toner) require the image be bleached first before the toner can work. The final result is the addition of a totally different color from the original print. Additive toners in a wide range of colors are available from the antique warm brown of sepia to blue, red, and so on. Of this group, sepia toning followed distantly by blue toner, are the most commonly applied. In addition to the example of sepia toner shown here, the advertising section (page 127) has a photograph of an ear that was warmed up in color by sepia toning. Although sepia toner is more familiar, due to usage, this does not mean that it should be applied without careful consideration.

Due to the coldness in color of blue toner, it places a distinct limitation on the variety of subjects that benefit from its application. In general, inanimate objects like buildings, cars, and scenics are far more appropriate than a subject like a portrait where warmth is expected. Blue toner can be used on a portrait, but its coolness will add another element of surrealism or hardness that is usually not flattering.

The old-time quality created by the sepia toner complements this image. It is a scene that is, was, and will be continually repeated over time. Judgement on which version (sepia-toned or untoned) is more appealing is subjective. I find the changes created by toning are acceptable but unnecessary. Nothing is added to the photograph that makes the image more than it already is.

When compared to the sepia-toned and the untoned prints, this version is unacceptable. A cold, surreal effect replaces the warmth and familiar character of the scene. However, when this version is viewed alone, the transformation appears less radical and has an eerie effect that is interesting and acceptable.

As this example illustrates, the use of toner requires experimentation, consideration, and comparison. The effect and character of an image are the key issues that determine the selection of a toner.

Boston, Massachusetts. Leica M-3, 35mm Summicron lens, Tri-X

This image is successful without the use of toner. It is the result of waiting for the person with the right motion to run through the lighted area of the scene. Many other people of various sizes, shapes, and movements ran by, but some element was lacking in each. The blur of motion is a good contrast to the peaceful late afternoon scene. Allowing the lighter tone of the background to become washed out creates a brightness and instills a feeling appropriate for the shot. As a result, detail in the foreground is maintained. The necessary contrast highlights the runner and adds a balance to the strong shapes, lines, and piece of sky in the top left corner.

SHOOTING IN COLOR

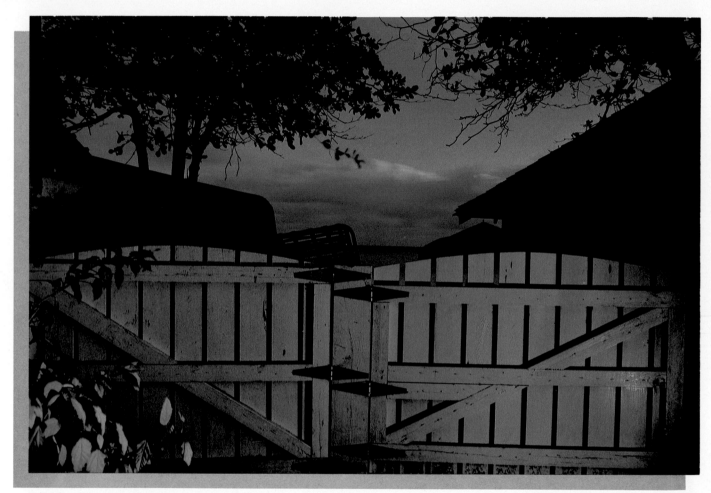

Barbados. Nikon F-2, 28mm lens, Kodachrome 25

"The limitations of the process are balanced by the infinite variation and effects created by color."

There are inherent limitations in shooting color due to a lack of latitude in the film and fewer controls in the process compared to black-and-white. These are boundaries that must be worked within and employed to their best effect. However, the often-heard statement about color photography, "What you see is what you get," is true in many respects. The limitations of the process are balanced by the infinite variation and effects created by color.

The exposure of color film, slides in particular, requires precision. To a degree, alterations in processing can compensate for this lack of accuracy, but it is costly and results in increased contrast, grain, and the additional loss of detail. Without compensation, a slide can be at most ⅓ to ½ stop underexposed or overexposed. For negative film, the margin of error increases to ½ to 1 stop. However, the ability to control the loss of detail due to the makeup of the film is not possible.

Within the printing process, certain controls (some also found in black-and-white) permit the print to be changed to a moderate degree. Color can be corrected to more closely match that in the original scene, or it can be changed at the printer's direction. In addition to burning and dodging, contrast masks can also be applied. If these techniques are applied excessively, the areas lightened or darkened can change from their original color. The choice of a paper surface also has an effect on how the image is perceived. A glossy surface gives the appearance of having more contrast which fosters the perception of sharpness. A flat surface reduces contrast, and the image is seen more easily without the reflective gloss of the paper.

Although all of these characteristics apply to color printing, there are different types of prints made from slides and negatives, whose effects and processes are dissimilar. The most common form of color print is a C-Print. Color negative film is printed directly onto the paper. The strong saturation of color and the wider latitude of the negative provides a greater amount of control.

In the Cibachrome process, slide film is printed directly onto the paper which reverses the image back to a positive one. While saturation and sharpness appear more vivid than in the C-print, this is due to the much higher contrast. To a degree, this can be corrected by changing the paper surface, using a mask, or by altering the paper developer, but a loss of detail is usually seen in this process. Transparencies with a lower contrast range handle the contrast of the paper with far more pleasing results than an image with strong contrast.

A C-print, like those made from negatives, can also be made from slide film. For this to occur, the slide must first be made into a negative and then printed. Since another generation is added between the original slide and the final print, certain basic qualities are altered. A loss of sharpness, loss of contrast, and a loss of color occurs as a result of this process. The loss of color is due to the slide film's inherent bias for certain colors being transferred to the negative and the paper which have different color sensitivities.

Each film has its own increased sensitivity to certain colors as well as an overall color cast. Kodachrome 64 tends to be a bit on the warm side, a touch magenta, and has a strong sensitivity to red. Ektachrome 64 is a bit blue in cast; green and blue are seen more vividly. The photographer's choice of film is based on its final use, the color temperature of light source, grain, level of illumination, and the film's color bias. The choice and application of color film is selective, and is determined by the effects that are desired.

There are certain controls and responses to the temperature of light source and film available to the photographer that affect how color is rendered. In contrast to black-and-white, which captures all the light during the day in shades of gray, color film responds strongly to differences in the color. On an overcast day or in deep shadow, the inherent blue color of daylight is cast throughout the scene. The color is constant because the light does not change.

The color spectrum of light from dawn to dusk ranges from pink, orange, white, pale blue, back to pink. As a result, the color of light directly affects how the scene is perceived on film. Changes in the atmosphere affect the color of sunlight. Exposure and the camera angle to the sun affect how color is seen. The experience, sensitivity, and resulting judgment of the photographer is the critical factor. The final decision and perception determine how the color of daylight affects the subject.

MONOCHROMATIC COLOR

A color photograph that is described as being monochromatic uses one color from any part of the spectrum and/or has the total effect of one color, although different hues are present. By the use of this specific application of color, you add a necessary definition, or element, to the image. This characteristic separates and defines the difference between a monochromatic color photograph and one in black-and-white.

In this selective application of color, knowledge, understanding, and judgments developed for black-and-white are valuable and necessary. The fact that color is not seen as more saturated, due to the contrast created when other colors are present, neither lessens its importance nor diminishes its value. On the contrary, color adds definition, and is seen and used differently than we are accustomed.

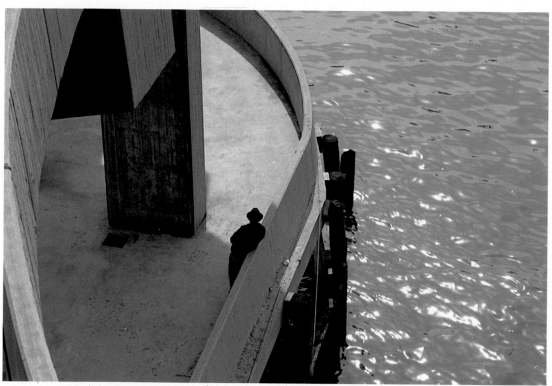

New York, New York. Nikon F-2, 100mm macro lens, Kodachrome 64

Contrast is the primary element that creates movement and balance. The frame is divided into two separate areas. On the right, color in a flat plane contrasts with, and balances, the neutral color and different planes on the left. Light creates the contrast that defines the man as shape, the edges and curves of the structure, and the highlights on the water. A strong curve of the light-toned structure is counterbalanced by the diagonal motion of the curved ripples on the dark water. The curve in the cement above is answered and continued below. While the curve of the shadows returns the eye to the man, the contrast of planes makes motion continuous.

Only the steel blue/cyan color of the water is strongly seen. But, as you look at the highlights, your eye automatically produces the complement yellow or magenta in this area. The added color in this shot is necessary. A strong use of characteristics of light and tone are associated more with black-and-white. It is the color of the water that acts as a defining element, creating a contrast with the area on the left.

Barbados. Nikon F-2, 28mm lens, Kodachrome 64

A rapid sequence of events preceded this shot and made it possible. When I first saw this scene, the white puffs blowing across the frame were not there, and it was not worth shooting. Moments after turning my attention elsewhere, a strong gust of wind created the missing element. Jan saw what had occurred, and grabbed me to get my attention. I knocked off a couple of frames, and then it was gone. The vision of another coupled with my instant response produced this result.

Without the green foliage to define the spring season, this would look like an early winter snow scene. The white puffs, which stand out strongly against the dark background, are close enough together to be seen in patterns. There is a rhythmic visual motion that is created by the high contrast of light that enhances strong light-to-dark relationships. From foreground to background, the movement in tonalities is evident; dark foreground, bright middle, dark shore, and light window.

The contrast of tone creates motion and establishes relationships within the elements on the pond's surface. The dark stems with bulbs are prominent due to the white sheen on the water. This not only creates movement front-to-back, but offers a balance (though reverse in tone to the snow above) by forming patterns on the water.

Although the scene is perceived as being only green, the high contrast of the light further dilutes the muted color throughout. Other colors can be seen in the yellow/reddish-brown lilies in the background, and magenta occurs in the background and on the front of the building. The sides of the building are tinged with cyan. A monochromatic image need not have only one color, but it must be perceived that way.

OVERCAST LIGHT

When clouds block the strong directional light of the sun, a passive quality to the light is left in its place. The illumination that is seen is gentle or soft due to its lack of definition. Color is not diluted or strengthened by the highlights and shadows from the sun. Since the contrast is low (flat), the limited latitude of color film can maintain all the detail within the scene. However, in the case of backlighting or a dark scene with overcast sky, selective exposure for one area or another is still required.

The rendering of texture, shape, and contrast is far more subtle in translation because it is defined by the subject rather than the direction of the light. Consequently, overcast lighting is not the perfect light for every subject. When used correctly, the results can be dynamic and subtle at the same time.

A passive, yet gentle quality of light allows color to be seen as luminescent. This lack of definition and contrast in the light and the scene results in the area being seen as expansive. The sand appears to have a softer texture. Now, the smaller, darker areas of primary colors stand out more vividly against the sand. A subtlety in the light-to-dark relationships in the sand creates a continuous weaving motion around the frame. To complete the balance and motion, the children's legs provide context and answer, through proximity and similarity, to the vertical supports under the frisbees.

The subtle effects of the light are used to the best possible advantage. For this shot, the subtle and passive quality of light is necessary.

Ipswich, Massachusetts. Leica M-3, 35mm Summicron lens, Kodacolor 100

▷ After driving through an area of urban decay, I came upon a group of boat hulls that had been dry-docked. This image is the result of trusting my instinct without questioning it. The squalor and decay of the area made the vibrant color and beauty seen in this shot stand out more clearly.

The warmth and saturation of the red/orange area combines with contrast of hue to draw the eye into the scene. Shapes that create motion in the painted area are repeated by the blades of grass and shadows below. Although the bottom left corner is a relatively quiet resting place for the eye, it defines the separation of planes. The continuous repetition of blades of grass brings the eye to the white twig, to the metal sheet, and then, to the overlapping blades on right.

An inherent contrast of tone exists in this shot. Darker tonalities around the border frame the color and patterns on the metal. The strength of light-to-dark relationships, combined with vivid color and vertical framing, are balanced by a fluid visual motion, passive light, and warmth of color. Strength, beauty, and a tranquil feeling are the combined effect.

Virginia Beach, Virginia. Leica M-3, 35mm Summicron lens, Kodacolor 100

CONTRASTY LIGHT

As stated before, light, which is perceived as having direction, creates contrast. Direct sunlight and electronic flash are not only perceived by their effects on a subject or scene by directing visual movement; they also have their own importance. An awareness of light and the direction it comes from are definable qualities. Highlights and shadows are created and defined by this type of light. Size, shape, form, and space are now the characteristics that describe the shadows. While edges are more sharply defined by this contrast, texture and light-to-dark relationships are enhanced as well. Directional light highlights the subject and separates it from the background.

A backlit scene is a special form of directional light. The drama it creates is due to the amount of detail that is omitted. Exposure can only be made for highlights or shadows. When film is exposed for the highlights, the subject will be seen in sharply defined outline, shape, and form due to the lack of detail and lack of contrast.

Options in the printing process, like burning, dodging, and masking, cannot effectively compensate for the inability of the film to hold all detail in the shadows and highlights.

How color is rendered is no longer viewed exclusively by saturation but by contrast in tone. This does not mean that color will no longer be vivid, only that its perception can be enhanced or diluted by the contrast of light. Awareness of light and its effects expand to include the effects that adding color can create.

Whether it results in silhouettes or illuminates the side of a subject or scene, an active quality can be attributed to directional light. It defines and creates motion on its own and by its effects. There are no controls in the color process that are comparable to those seen in black-and-white. The decision rests with the photographer's knowledge of color film through experience to determine the effect that will be created.

Port Antonio, Jamaica. Nikon F-2, 28mm lens, Kodachrome 64

New Jersey. Nikon F-2, 100mm macro lens, Kodachrome 64

◁ After checking into a hotel, I decided to investigate my surroundings. This image, seen from the restaurant as I was looking down at my patio, required that I decide how I wanted it to look on film. Because of the high contrast of the scene and the film's limited latitude, exposure detail could only be held in either the highlights or the shadows. Since the detail in the shadows was not critical and the blocks of space the shadows formed were acceptable, the exposure was made to hold the tone and texture in the more dominant highlights. The shapes of the shadows create a frame below and visual balance to the motion above. The use of the film's limitation results in a graphic, strong, and moving photograph.

The only color appears on the brown panels of the roof and the reddish-brown of the floor below. Both areas stand out due to contrast, but on top it is dark on a light background while below the tones are reversed. Small size, similar shape, and good contrast allow the chairs to be seen as the subject. A continuous line from the white panels to the white divider and curves of the panel edges facilitate motion throughout the frame. In addition to the similar rectangular shapes on the top and the bottom, the shape of a triangle is repeated on the sides of the roof and on the patio below.

△ The distribution of tonality made exposure of the film a simple decision. By maintaining the color, tone, and less contrasty light-to-dark relationships in the sky, the sky acts as a necessary balance to the strongly defined edges, lines, and darkness below. Also, the clouds and blue sky can create visual motion across the frame. If the exposure had been made for the shadows, the larger area of the sky would have become so light that the eye would be drawn out of the frame.

The lamp post on the left plays a very important role. Not only does it act as a visual connection between sky and ground through proximity, but it is also an anchor that slows the horizontal motion by redirecting it up-and-down. Repetition of other vertical posts in the fence reinforces the importance of the lamp post. This similarity adds a necessary contrast in direction to the horizontal line in the fence. The man on the bench, gazing towards the approaching bicyclist, also redirects and slows horizontal motion.

The high contrast of backlight sharply defines the shapes and the lines. A strong, continuous visual motion seen in the fence and in all directions within the frame is caused by the contrast of light. Shapes of a triangle, a circle, and a rectangle are repeated continuously. The similarity of shape establishes other relationships that create movement.

Ipswich, Massachusetts. Leica M-3, 35mm Summicron lens, Kodacolor 100

Look closely at this shot. Turn back to page 86 and compare the effects that are created by a different quality of light on the same subject. Radical changes are seen in texture, shape, line, motion, color, and the definition of these characteristics. This comparison of the different lighting situations clearly delineates the passive quality of light on an overcast day, and the importance of the directional light.

In this backlit situation, the exposure was made for the shadow area. The bleached-out quality of the sand creates a strong continuous motion that is familiar for a beach scene. The high contrast of the light sharply defines line, shapes, and shadows, and the gritty texture of the sand. Color is seen strongly because of the contrast in tone rather than saturation. Light-to-dark relationships are more clearly defined.

The other concept that should be noted is the possibility of effects created by exposure in a backlit situation. The two shots of the beach show the result of opposite choices in exposure for the scene. Each decision was right for the scene. Because the sand castle shot has no large area of light tonalities that would dominate the image and cause the eye to be pulled out of the frame, exposure for the shadow areas was possible.

Shapes are seen clearly and establish relationships that are important to visual motion. The curve of line and circle in the boy's cupped hands, and the design of the T-shirt collar and sleeves, is repeated throughout the rest of the frame. A triangular shape is formed by his arms, legs, and shadows, and is continuously repeated in the sand castles, people, and sand roadways.

GARISH COLOR

When a scene or person is described as being garish or wearing "loud" clothing, it usually refers to the unusual combination of colors. As eye-catching as the total picture may be, the viewer may experience a certain duality. Dissimilarity is the magnetism, and yet, a certain repulsion may exist simultaneously, not unlike morbid curiosity. Sometimes color combinations are so striking precisely because of the bad taste so flauntingly exhibited by the person or the scene.

Our day-to-day life in the United States is not filled with rich, contrasting colors. A homogenized use of color is repetitive and predictable. Amusement parks, nightclubs, and carnivals use color to signal frivolity and define a different experience.

Other cultures and areas utilize color differently. For instance, in Canada, houses are painted in multiple colors to break the monotony of the white snow and as a way to distinguish one's house from the others around it. Vibrant colors are indigenous to the clothing and painting of houses in the Caribbean. A sense of freedom and a carefree quality is often associated with this area, reflected in the unusual use of color.

The line between a garish or loud color combination and simply bad taste is a rather fine distinction. For the photographer, experimentation with and use of unusual color combinations is necessary and selective.

For color to be seen as lacking harmony, the strong saturation of color must be magnified by strong light-to-dark relationships and tonal contrast. This makes the definition of space and color, by contrast, far more vivid.

Rye, New York. Nikon F-2, 28mm lens, Kodachrome 64

A strong contrast in tone, line, light-to-dark relationships, and direction enhances the perception and importance of color. Visual rhythm and motion are fostered by the balance of contrasting direction of line and color as they overlap one another. While the diagonals of light cross up and to the right, the curves of the fabric move horizontally from right to left. In the bottom right corner, the "fan" of metal bars spreads in all directions but downward. The support beam at the bottom of the frame runs horizontally and up to the right. To complete the balance in direction of movement, the small vertical edge on the left side does the job.

Additional enhancement of color is created as the bright lights cross the frame, overlapping and intersecting the saturated color in the background. Only the bottom light intersects all the curves. As the lights diminish in size, they intersect less of the background.

The more subtle relationships created by the colors reflected or transmitted through the background are important. Other colors are seen in the bars, the base of the middle light socket tinged with red, cyan on the "fan's" base, and orange on the support pole. Although less striking in effect, this blending and reflection of color reduces contrast. It causes additional and more subtle relationships that add to the visual motion.

New York, New York. Nikon F-2, 100mm macro lens, Kodachrome Type A

△ A continuous line of wood combines with the borders of the photograph to frame each area into different, yet related, areas. The contrast, created by electronic flash, adds to the unusual combinations and contrasts of color. Adding the odd light blue of the sky, caused by the use of Type A film in daylight, increases the contrast in color and tone.

Although the color and the scene seem to lack harmony at first, balances in the design of the elements within the frame provide an order. In the bottom left corner, the line of letters against the pink wall are "mirrored" on the right by the musical scale on baby blue. Snoopy and Charlie Brown (wearing bright red) stand out strongly against the off-blue sky and trees beyond. The brownish-pink rail continues across to the red frame and the green railing to the right. While the lighter blue sky and tree branches repeat the elements to the left, the vertical rails create a visual link to the scales below.

Each area is divided and framed, but within each world a continuity of line above and below, and a relationship side-to-side exists. Even the curves and circles in the notes are repeated in the letters, hat, tree, bell, red rivets, and green circles. The color combination does have a garish quality, but order and balance make it seem more palatable.

▷ At first glance, there seems to be something askew or off about this shot. In many respects, although this is true, as a whole there is an order that is balanced and beautiful.

There is something odd about the scene with the curtains blowing outward rather than in, the turquoise shutters, the painted windows, the orange walls, a tilting door, and a dark-brown floor. However, the dark floor serves as a necessary visual anchor. The potted plant and light bulb (askew on the ceiling) balance and redirect the motion of the curtains.

This balance makes it possible for the light curtains to be seen as a frame highlighting the boy. Repetition of the curtains and the proximity to wall and door, leads the eye back to the unexpected turquoise door and orange wall at the end of the hall.

The boy's placement off-center and back in the frame gives him prominence in his environment, and presents a visually stronger image. As the curtains above frame him, his dark skin tone is contrasted and set apart by the door. His small size and curled-up position is further enhanced because he interrupts the continuous line of floor and wall. Had he been placed in the center or right side of the frame, there would be little to emphasize his importance.

The order and balance in design with strong light-to-dark relationships makes the color combinations and incongruities seem harmonious.

Guadaloupe. Nikon F-2, 28mm lens, Kodachrome 64

PASTEL COLOR

When different colors in the same shade or of very similar color saturation fill a photograph, their cumulative effect is passive and gentle. This lack of contrast results in the colors having the appearance of blending into one another. Usually the feathered light of early and late day overcast light, or reflected sunlight are responsible for further reducing definition that adds contrast and separation of color. But it is the lack of colors meeting sharply, separating, and defining each other that creates the subtle relationships and luminous quality.

While we use contrast to define depth, texture, color, size, and so forth, the total lack of contrast is more difficult for the photographer's eye to develop. In the black-and-white section (page 70) two examples rely on the subtlety that can be seen and used by the process. For color, this specific application of more than one color without contrast is the same subtle use of the color process. The photographs in "Overcast Light" show the effect light has on color, but this is the effect of color combined with light as a necessary but non-defining element. It is an effect that is pleasing due to blending, and not demanding due to color definition/separation.

New Jersey. Nikon F-2, 100mm macro lens, Kodachrome 64

For this shot, direct sunlight reflects off the cropped-out buildings in the background. Although contrast of tone occurs in the reflections, it doesn't define the edges of color, only neutral space. Color blends together because of the similar tonality and color saturation.

As the eye moves from the out-of-focus diving board that comes out of the corner of the frame, the contrast and sharpness beyond creates a figure/ground flip. Ripples on the water have continuous motion as well. The less busy area in the bottom right corner acts as a place for the eye to rest. Proximity of the edge of the board and the repetition of similar shapes in the reflections add to motion side-to-side and front-to-back.

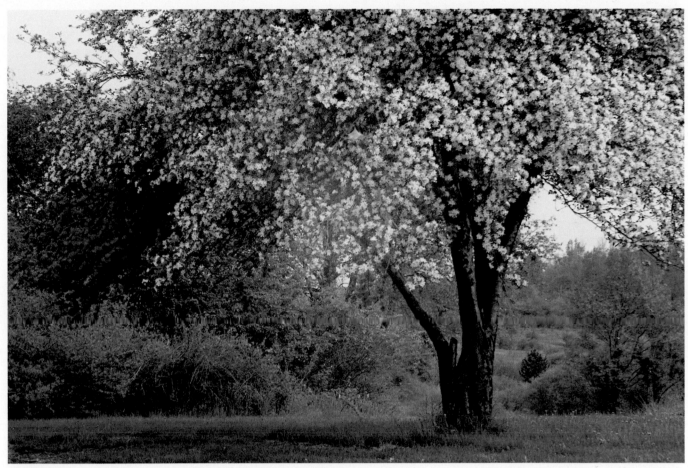

Lansing, Michigan. Leica M-3, 35mm Summicron lens, Kodacolor 100

There are days when both the heat and the humidity hit the 90's and the air seems to have a discernible weight. When a photograph is shot on a day like this, the moisture and pollution diffuse the light which then mutes color. In this case, the flat, diffused light creates an effect of tranquility and harmony.

The dark neutral color of the tree trunk acts as a visual anchor that connects the ground and leaves above. Visual motion is created by the blending of tone, texture, color, and the subtle rhythm of light-to-dark relationships.

A small patch of sky under the tree repeats and balances the top left corner. The lighter edge of the bushes leads the eye back to the light area framed by the darker trees. It creates a visual balance to the white tones in the tree.

BLACK-AND-WHITE AND COLOR

A photographer does not magically change from shooting black-and-white film to color film without a transitional period. Each process has its own boundaries and effects. Two completely different ways of seeing with a camera are necessary. As a result, the eye must be taught how to see differently for each film.

Due to a severe backlog in printing and processing of black-and-white, I decided to shoot color film because I could send it out for processing. Although color seemed easy and fun at first, I then realized that I had no idea what I was doing. I had no concept as to why things looked as they did in color. My solution was to carry two different cameras with a different film in each one. By shooting the same subject in black-and-white as well as color, comparison was possible. Understanding what did or didn't work became clearer. Two different formats (35mm and 2¼″-square) with different lenses helped to break the monotony. Contact sheets, and sometimes proof prints, from each film offered a quick and less expensive way to learn.

This process took time, money, and exploration to provide some glimmer of understanding. Watching a color television and alternately shifting the picture back-and-forth between color and black and white, was a quick, accessible option that was very instructive. Paintings, animation, films, and the color photographs of professionals opened my eyes by providing an overview of what was done and how color was used in each medium.

While black-and-white most strongly represents the craft and generates an intellectual response, color creates a feeling that elicits a more emotional chord in the viewer. Both are translations of reality but color photography is a much closer representation. An initial advantage to a print in shades of gray is that it is different from reality so a curiosity factor is already built-in. The same curiosity exists for a color photograph, but it is based on its familiarity.

CONTRASTY LIGHT

Black and White: Relies on and renders contrasty light more completely than color. Fewer limitations of film latitude and processing offer more control and variations.

Color: Because the film has less latitude and fewer controls than black-and-white, greater precision in exposure, and more attention to loss of detail and its effects, is necessary. The quality of light creates contrast in tone which also directly affects how color is seen in saturation.

OVERCAST LIGHT

Black and White: The soft, flat light eliminates many of the light-to-dark relationships. Although it is possible to use this light effectively, the effects and dynamics are very different and more restricted.

Color: The colors are seen as more vivid, or luminescent. Loss of tonal contrast is replaced with contrast of color and hue. Latitude of film can better hold the detail in highlights and shadows.

Each process requires a different way of seeing, with respective boundaries that one must understand and work within. For these reasons, the choice of film is as selective in application as any other tool or control. One image will not have equal strength in both processes. It is an either/or situation with one film's properties being more completely applied.

With each set of examples, cover one image as you look at its alternate translation. Then reverse the placement of the paper. It is necessary to look at each image separately in order to see its respective strengths and weaknesses before being able to make an informed comparison for your own benefit. In the shots of the dresser and picture park, the weaker image of the two is not bad by itself. But when seen in comparison, its effects and weaknesses are more clearly visible.

Duxbury, Massachusetts. Mamiya C220 2¼"-square, 80mm lens, Tri-X Pan Professional

This shot is about the quality of light and the effects it creates as it falls across the surface of the dresser. By defining and enhancing texture, shape, line, edge, and shadow, the subject is seen in a way that is far more grand and beautiful than it ever is in reality. The quality of light not only complements the subject by making it dynamic, but it has an importance and definition all its own.

Black and White: The wide range of tonality in this print uses the contrast of the light to define the subject, and by maintaining detail, gives it an expansive quality. On the far right, the black area acts as a visual resting place as well as a balance to the strong visual motion in the rest of the frame. With this contrast of tone, the now strongly rendered edge of the dresser is repeated in the shadows. Strong visual motion of texture and edge is balanced and redirected by the angle of the horizontal divider between the drawers and top edge of the dresser. The use of a small section of the dresser and higher contrast combine with angle to bring the eye back into the dresser.

Color: The special qualities that color adds to the shot are diluted by the limitations in latitude of the film. As the shadows lose detail and are reduced to blocks of space, the highlights become more dominant. Subtlety is vastly diminished as the loss of detail reduces the element of texture to an element of contrast. As a result, the divider between the drawers increases in visual importance and continuously returns the eye to this focal point. Balance is reduced and usage of the entire frame is not effective or complete.

Since this was my first color photograph, I had no knowledge that a time exposure could create a shift in color. The greenish cast seen here is an example of what happens when color film is used incorrectly. Other films can handle time exposures without this shift (with or without color filters to compensate). Fortunately, the quality of light and natural color of the dresser are not overwhelmed by this unforeseen color shift.

Boston, Massachusetts. Canon F-1, 50mm lens, Kodachrome 64

BLACK-AND-WHITE AND COLOR

Daytona Beach, Florida. Rolleiflex 2¼"-square, 80mm Zeiss Planar lens, Tri-X Pan Professional

Daytona Beach, Florida. Leica M-3, 35mm Summicron lens, Kodacolor 100

△ Unlike the other examples, comparison is not necessary to see more clearly the strengths or limitations of each process. These prints illustrate the fact that there are images that demand a particular film to communicate. The subject and scene demand color because they create humor, beauty, and whimsy. This is a color photograph with no doubt or argument possible.

Black and White: Unlike the example of the picture park, this image becomes lackluster in black-and-white. The lack of contrast in the scene, background, and light dilutes the visual strength of the unusual subject. As a result, the light-to-dark relationships lack the impact and/or subtlety to create and to maintain visual motion.

Color: The addition of color defines and imparts a whimsical quality to the image. Relationships caused by color in contrast and in similarity, separate and integrate the elements and space more effectively. The proximity of sky and circus-like environment permit the elephant to connect these two separate worlds. Horizontal motion of the clouds, with their subtle light-to-dark relationships, balances the contrast below. As distinctly separate as the elephant is to the sky, due to color, the clouds appear to be coming out of the elephant's curled trunk. The color communicates the humor and beauty of the scene.

▷ Both of these images effectively use the strengths and push the limitations inherent in their respective processes. A lack of contrast, due to flat light, is compensated for by the contrast and strong light-to-dark relationships in the black-and-white version, while the heavy saturation of color, due to the passive quality of light, adds an electricity that is far more effective and dynamic in defining the scene.

Black and White: The inherent contrast of the scene and odd grouping of elements is sufficient to draw attention to this shot. In terms of design, the motion is maintained throughout the frame after the initial curiosity is created. The scene, somewhat incongruous in nature, is viewed with a certain detachment because the reality of it has been altered by translation into shades of gray.

Color: A seemingly garish color combination in conjunction with the supposed reality of a color photograph, makes this shot far more dynamic. The bizarre nature of the scene, enhanced by color, has a certain surreal quality. Response is more immediate and emotional than it is in black-and-white. It is color that defines and exaggerates the scene, making it more unreal and seemingly distorted.

Quebec, Canada. Hasselblad 500cm 2¼"-square, 80mm lens, Tri-X Pan Professional

Quebec, Canada. Leica M-3, 35mm Summicron lens, Kodacolor 100

PHOTOGRAPHING FOR YOURSELF

Amsterdam, Holland. Leica M-3, 35mm Summicron lens, Kodacolor II

"To me, photography is a great amusement that generates a response unlike anything else."

Whenever I pick up a camera, I am aware of a certain electricity that seems to run through me. An inner strength seems to make me quicker, more intuitive, and more aware of what I see. At the same time, a certain deadening of my awareness filters out anything not relevant to the shot or scene before me. I cross streets and move through crowds with a total lack of conscious thought. To me, photography is a great amusement that generates a response unlike anything else.

Other endeavors in my life produce a unique feeling and response, but photography provides its own unique challenges and satisfactions as well. After all these years, I am still curious and fascinated by what the camera does and enjoy the lack of limitations that it provides. Endless possibilities exist, and that freedom is priceless. But it requires that a self-imposed order be created to provide a framework in which to direct energy. This freedom is a responsibility; my images are made for my own benefit. No one else can take the blame for my frustrations and failures. I answer to myself and this is a precarious position. For whatever reason I convince myself that an image is good, if it isn't, then I have only fooled and lied to myself.

The "great" shot is not really what I hold as most important. It is the image that I will take tomorrow that make me shoot more, not what I have already done right. This does not mean that the good shots have no value and meaning. Although they are so few in number compared to those that didn't work, they provide the tangible evidence of having done something right. In a way, they are like road signs that tell me where I have been. They create a standard against which to measure future images. The evolution of vision and enjoyment of the process is the real motivation.

Ideally, each picture would be perfect. The theoretical goal is to get better and better. However, if I could always shoot at that level, what else could I arrive for? What else could I learn? It is a goal that is unattainable, and not really wanted. Once I cease to learn, and lose my curiosity and sense of expectation, then it will be time to move to another field.

A photographer is an observer; detachment is created by the camera in front of the eye. Yet, I still "see" without my camera. Constantly having a camera in my hand or on my shoulder is not going to make me feel more like a photographer, just less of a person. Countless possible shots have been missed due to the lack of a camera in my hand, but what has been seen stays in my memory and will eventually show up in the photographs of the future.

Each photographer has his or her own viewpoints and definitions. Other sections in this book reflect my perceptions in various and lesser degrees. The questions you must ask and the boundaries you must define about your own work hopefully will be clarified as you reflect on my own perceptions and awareness of the process.

CROPPING

Cropping a photograph is a question and an issue. In commercial work, the dilemma is solved by the need to provide the designer or art director with an image that will work effectively. The photograph is going to be cropped and not used full-frame. Instead of the boundaries of the frame, the photographer works within the limitations of the design established by the client. Consequently, cropping the photograph is a pretty cut-and-dried decision.

When the photographer approaches his own work, cropping presents a dilemma that he must solve. For some, myself included, the full frame is a boundary that is respected and used completely. Total usage of the frame is not only expected, but serves as a self-imposed limitation and a continuous challenge. But I do not see it as a sacred line that, if altered, devalues the worth of the image. To have the latitude to remove undesired elements from the frame, when it could not be done in the camera, is a valuable tool.

If cropping is necessary to make the image work, then it should be cropped. This is not an excuse to clean up photographs that are consistently careless in vision and lacking in design. There is a logical mid-point between the purists and the weak designers.

To me, a black border around the print is a visual statement of the complete usage of the frame and nothing more. I prefer to crop in the camera and not in the print whenever possible. Many years ago, as many images in this book show, I felt that the inclusion of the black border on my uncropped images was unnecessary and an incomprehensible display of ego. Today, I see it as a visual statement of sound design for myself, but I do not view it as a requirement to measure the value of the image or my work. However, I will not show cropped images in books or magazines with a black border placed around them. I can happily live with the idea that some of my images are cropped. But, I would find it impossible to live with myself if I showed these images as if they were full-frame. A black border is a signature of ego as it is, but, for me, to add it to cropped images represents a lack of integrity, insecurity—and it is a lie. My integrity has far more importance than my ego.

The examples shown illustrate cropping the print to enhance the effect in the final version. There are times when the camera format and/or the lenses owned are not the best solution for the scene that is being photographed. As a result, the image should still be shot and then cropped in the printing process. For this scene, the 2¼"-square format has been altered by cropping to a horizontal and rectangular frame similar to a 35mm.

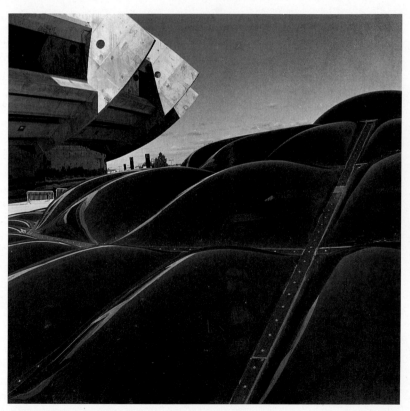

Montreal, Canada. Rolleiflex 2¼"-square, 80mm Planar lens, Tri-X Professional

Because of the square format of the camera, the higher contrast and lighter tonalities in the building are included resulting in a figure/ground flip. The highlights on the domes act as a visual answer to the similar shapes in the building. Although this is a totally different effect than the cropped image, it is a good approach to this scene. But it is the empty space above the domes that is responsible for the interruption in visual movement. Once the eye is led to this area, the only place it can go is back down the dome.

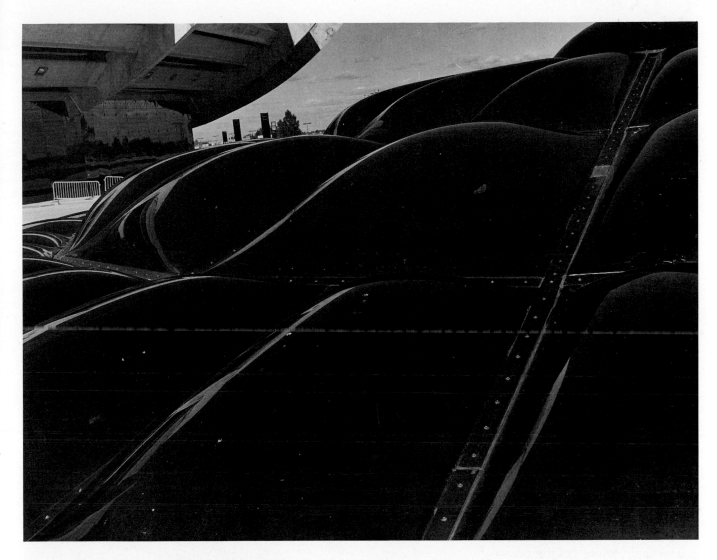

By deleting the dead space of the sky and reducing most of the large section of light tonality in the building, a totally different photograph results. Now, the domes are seen as the subject. The curved highlights against the black metal bar have an increased visual strength that creates a continuous line of motion. The building, now seen as background, and its shapes repeat those seen more strongly in the dome. A line of clouds, increased in importance through cropping, acts as an additional visual connection between the domes and the building.

LUCK

Luck is a continuous part of our daily life. When you are late for an appointment and the traffic is light, it is luck working in your favor. However, you need the skills, experience, and knowledge to be able to use luck to your advantage. Without these qualities, lucky situations can become wasted opportunities.

Aside from the mechanical failures that can occur, a good eye, experience, and quick reactions are important if the photographer is to use luck to his advantage. It is not skill that creates the perfect light for a subject just as you arrive. But, how a subject is seen with a camera is luck applied with skilled and discriminating vision. As a result, any photograph, commercial or personal, is based on how luck is controlled and used creatively.

However, there are certain acts of fate, due to carelessness, curiosity, or circumstance, that the photographer finds inadvertently work in making an image much better. Such things as a wrong ASA/ISO setting, an unseen person walking into the frame during exposure, incorrect film for the lighting conditions, errors in processing of film, and so forth, can all create spectacular results. Amateurs and professionals alike have at least one shot that is based on some act of fate. When it works in your favor, it is great. If not, it causes great frustration and anger at the source that created such a dismal failure. However, if the shot looks better due to the error, its value is not less. It was just lucky that it turned out that way.

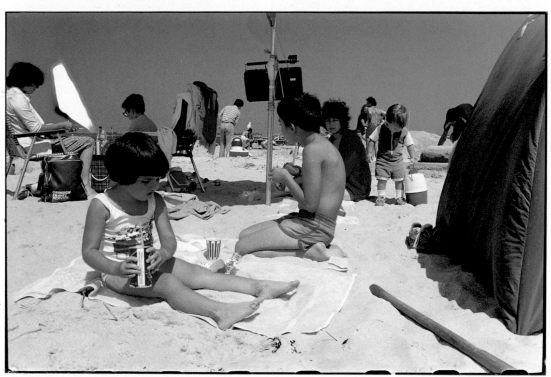

Ipswich, Massachusetts. Leica M-3, 35mm Summicron lens, Kodacolor 100

The white triangle that looks like a reflector is actually the result of an error that occurred during the processing of the film. By winding the film too tightly on its spool, the emulsion of this negative was touching the acetate on another piece of film. Consequently, the chemistry couldn't penetrate this area, and the undeveloped triangular shape is the result.

Personally, I find that it adds an element and dimension to the image that is necessary and enjoyable. If you place your thumb over this area and look at the picture, it is pretty dull without it.

Initially, my reaction was one of irritation. Being a purist for the moment, I felt that the image was not as I saw or planned, and therefore it should be discarded. But this view changed as I continued to look at and enjoy the shot. Without the error, it is unusable, so why not take advantage of what occurred?

True, I did point the camera, focus, and see the scene, but luck makes this shot work, not skill. Its value is not diminished. In fact, I find it relatively amusing that it worked out so well.

Guadaloupe. Leica M-3, 35mm Summicron lens, Kodacolor 100

The intense heat of the day was the catalyst that began a series of events leading to my photographing this scene. After the car engine stalled out, an unexpected downpour followed within seconds. When the rain abated, I grabbed my gear and sought shelter from the heat and humidity of the car. I ran onto this porch. As the rain again intensified, I was forced farther back on the porch and saw this scene. The image is a perfect example of luck applied with skill.

An effortless blending of beauty and irony work together to create this image. The quality of light gently illuminates the glowing color of the flowers against the pastel background.

Because of the camera angle, the flowers are seen as both the subject and an element of the setting. Patterns on the tablecloth create a strong, but gentle, visual motion balanced by the expanse of the walls.

The plastic flowers are resting on a tablecloth with a pattern made of flowers and stems connecting them. As you look at the flowers in the tablecloth, it becomes apparent that the line between them is formed by the stem of a flower. This juxtaposition is a little strange, but not so disturbing a contrast to detract from the beauty of the scene.

OBJECTIVITY

Objectivity is a very difficult attitude to develop towards your own work. Over the years, a couple of techniques that I have found to be useful are:

• Take the photos that you like, but are ambivalent about, and throw them in a drawer for three to six months. Memories of the day, your mood, and your companion will fade over time. You can then view the image with less emotional baggage attached.

• Take all the photos you like, but are unsure about, and put them all out on the floor or on a light box. First look at them individually and then as a group. By comparing, you can edit those that are best. I keep a group of slides and prints that came close but didn't make it as reference material.

• *Listen* to, but don't ask what people have to say about your photographs. If you ask specific questions, you will hear what you expect to hear. Show the images to non-photographers because most photographers have their own particular vision of the world. Mull over what you have heard, discard what is not pertinent, and make your own decision.

For example, beautiful women have looked awful in my photographs for years. My lack of objectivity made it impossible for me to see the bad lighting, messy hair and wrinkled clothes. So, after years of mediocre photos, I stopped using women as subjects and began to use them as part of the design. I still am working on being more objective, but it is a function of persistence and patience.

Since the boundaries are self-imposed and the results are solely my responsibility, I can only answer to myself for my failures and successes. Although I know that the really good images will be far outweighed by the mediocre, a consistency is what I would like to strive for and maintain. Objectivity is something that should be sought after, but the curiosity and personality that you bring to your work shouldn't be reduced or distorted. It is a very fine line to walk, because you answer to no one else but yourself.

Commercial work requires absorption and putting yourself into the job, but, here, objectivity is far easier to maintain and is necessary. The boundaries are dictated by the client. Even though I must meet my own standards in order to be statisfied, the final shot has been created because of and for someone else. As a result, a certain level of detachment exists to insure that the final shot meets the client's needs, with the extra touch that I can bring to it within those established boundaries. There is a great satisfaction and pleasure that I get out of commercial work. It is far easier than doing my own work, but it is just as difficult to maintain objectivity as it is for my personal work.

Guadaloupe. Nikon F-2, 100mm macro lens, Kodachrome 64

Jamaica. Nikon F-2, 100mm macro lens, Kodachrome 64

◁ When I first pulled this slide out of the box, I felt very pleased and excited. Rather than let it sit unseen, I showed it to others. The more people seemed unmoved, the more attached I became to the image. I was convinced of its value.

After a few months, I was able to view the shot with a more detached and critical eye. It is incomplete in execution. The painterly effect of light and color, reflections, and framing by the trees, with the balance between the boats, is a strong group of characteristics. However, something is lacking in the top part of the frame. Nothing balances or repeats the strong color and shape of the boat in the bottom right corner. In a way, it is like a question (color and boat) that goes unanswered (repeated). As a result, the top portion of the frame is useless and dilutes the photograph's strength.

Aside from the emotional attachment at the time, my strong response was based on its possible use of photography in a new way. The idea or vision is not complete, but the tangible evidence of another possible way to use the camera generated an excitement. It is a photographer's photograph, not resolved or complete, but it contains an idea for the future.

△ As you compare this photo with the previous one, the strength of this image is obvious. While it is an actual photograph of a scene, the other is a photograph about an idea or possibility. This scene is complete—all questions are answered—while the other is incomplete.

Another important comparison should be made regarding these photographs. When I shot the boats and saw the film, my excitement was palatable. There was an obsessed quality evident at both times. On the other hand, a simultaneous certainty and detachment was felt when the wall was photographed and seen after processing. Excitement generated by curiosity and newness usually does not result in a complete photograph. These incomplete images show me something new or something in a way that I haven't thought to shoot before. The unconscious awareness and confidence that occurs when the shot is what it should be is logical. It is complete, rendered as a tangible example of numerous ideas and things seen and resolved. Should it be exciting because it works? The good images are necessary, but the excitement of seeing more is the charge that generates more photographs.

WHERE IS YOUR WORK GOING?

A question that is necessary to ask is "Where Is Your Work Going?" Impossible to answer at times, sometimes irrelevant, and often counterproductive to the work you are producing, it is still important. Only by looking at the photographs that you have already done can you define possible future directions. Although this may seem similar to developing objectivity, the purpose here is not judgment, but an overview.

Two similar yet different approaches have been useful to me over the years. Once a year, I sit down and look over the work I have shot from the beginning to the present. This refreshes my memory and provides a frame of reference that gives me an overview of the evolution that has taken place. A perspective is created that allows me to trace the ideas, strengths, ruts, weaknesses, and consistencies in my work over time. This self-evaluation doesn't define the future, but it helps to define the present more clearly.

The other step I take more frequently is to evaluate the photographs shot over a year's time. Now my attention is focused on three groups of images: images that work, acceptable images that are not quite there, and ideas that are good but somehow unresolved. Although its a similar process to the general overview, the focus is more specific. The first group is looked at to establish a frame of reference and to boost my ego. Viewing the images that are incomplete permits me to evaluate what I missed that makes these images less powerful than the shots that work. Finally, I look at those images that had good ideas in order to understand what was seen. As a group, they are the most important because they form the basis from where future images will come.

If I am in a visual rut of constantly framing in a similar way, I will be able to see it and can correct it in the future. An unconscious evolution in how I see and what appeals to my eye becomes clearer. A more concise view of where my work is now and the possible directions for the future is evident. I look and see little that concretely answers my questions about my future vision because my vision is changing in a way that is not yet defined. My main concern is the overview and perspective. I do care what I will shoot next, but defining it is not valuable to me. My eye will go where it wants for now, and I am happy with this approach and accept it.

Many work on themes, ideas, or one subject over a long period of time. This process of evaluation is as necessary to them as it is for me. Although it is not how I work, I have a respect for this focus and fascination. A studied approach requires the continuous appraisal and comparative analysis already mentioned. It is neither right nor wrong, the choice is personal. Again it is difficult to ask and to answer questions about one's work. Because the focus on one idea or theme is more concentrated, it is somewhat easier to come to conclusions about one's work.

In contrast to my attitudes and my approach to my own work, very little conflict and few unanswered questions exist in relation to my commercial work. Since its purpose and creation is different, the question of where my work is going commercially is easier to answer and dependent on conscious decision. For example, I had a fine arts background and decided to go commercial in New York City. After a year, I decided to move from industrial work and turn my focus to the field of advertising. I asked these questions of myself, and continue to do so. What challenges do I want? What offers me more growth and uses my talent best in a way that will result in visual expansion? Will this choice allow me to live the lifestyle that I find enjoyable? However, these questions can only be answered by me, and they require the objectivity to ask myself honestly whether I am making a good or bad decision. These boundaries are more easily defined than those you continuously establish and change for yourself.

As a group, the following photographs provide an overview (limited but representative) of the evolution of my "eye" over an 11-year period. The purpose is to

New Haven, Connecticut. Canon F-1, 50mm lens, Tri-X

A simplicity and spare quality belong to this shot. Texture is an important element in this frame within a frame. Contrast of tone grabs the eye's attention and subtly maintains interest.

show a process that is usually reserved for classroom situations or in a retrospective, where the best and most representative images are shown. The value of these images is judged by the ability to illustrate and to trace how one person's vision developed, and refined, the basics seen in the earliest photographs. Early strengths and sensitivities are traced through time, and continue to the present.

Ten images formed a "portfolio" which were the first that I had ever final-printed. From this "portfolio" (loosely applied) that I created after a year and a half tutorial at Yale under Thom Brown, these two shots show a number of strengths that are repeated in my photographs

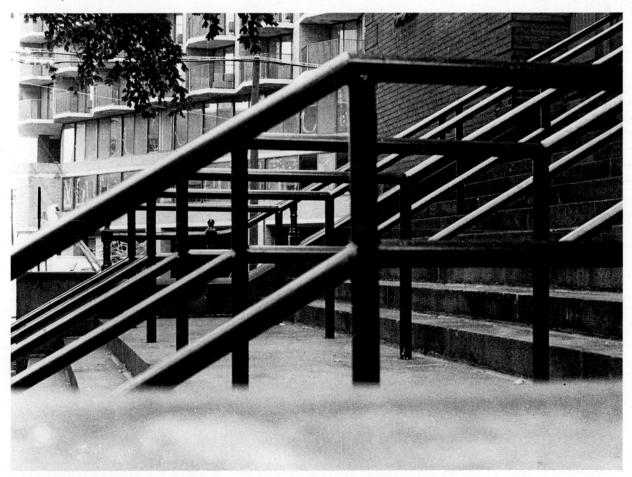

New Haven, Connecticut. Canon F-1, 50mm lens, Tri-X

An interest or sensitivity to graphic imagery is conveyed in this photograph. A sense of the motion that a strongly defined line and shape can offer is evident. In addition to the rhythm of the repeated rails, the subjects of rails, fences, and windows are often used in my photographs.

WHERE IS YOUR WORK GOING?

▷ An awareness and understanding of the black-and-white process is used with more proficiency now. This night shot combines the elements that were most strongly perceived in the first two. They are strength of line, graphic style, repetition of one element, continuous motion, reliance on the importance of texture, and design.

As a new process is studied, learned, understood, and then incorporated, the restrictions become fewer. A certain amount of energy which was diverted can now be employed and played with. While most of my early images were of definable subjects, the focus, at this time, was on form and abstraction rather than content.

▽ As one of my first photographs in color, it has a certain value that is worth studying. Because it was shot a year earlier than *Circus World* (opposite page, bottom), I have often wondered about this image. Was it just a fluke? Having seen the incongruity that certain unrelated elements grouped together can create humor and a surreal effect, did I unconsciously use this knowledge and apply it later in the documentary shot?

Boston, Massachusetts. Mamiya C220 2¼"-square, 80mm lens, Tri-X Professional

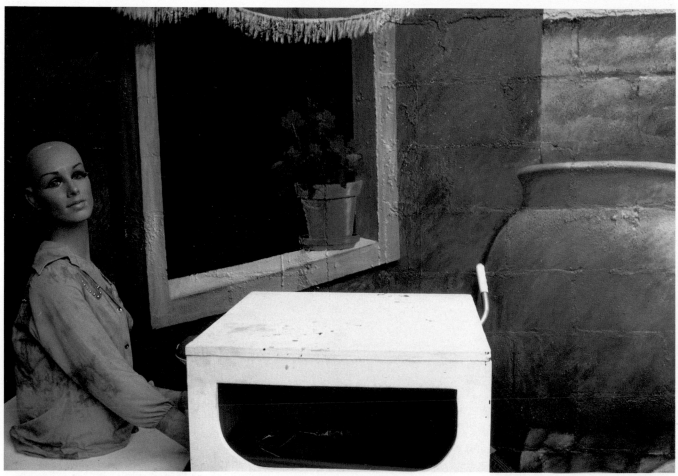

Hawaii. Canon F-1, 50mm lens, Kodachrome 64

Boston, Massachusetts. Canon F-1, 50mm lens, Ektachrome 200

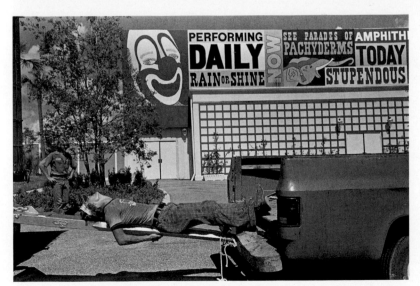

Orlando, Florida. Leica M-3, 35mm Summicron lens, Tri-X

△ This is part of the defining of color through selective use. To know the limitations of the process, application and experimentation are required. Although my lack of understanding color is relevant, it is the application of strengths stated earlier in black-and-white photographs that should be examined. The judgments necessary to black-and-white are also applied in a monochromatic color image. Strong visual motion, graphic nature, good balance due to light-to-dark relationships and texture are the elements that are now applied in color. A synthesizing and blending of knowledge and characteristics has been transferred to a different process.

◁ This image is a departure from the others in many important ways. By focusing my energy on documentary/street photography, people began to appear in my photographs more frequently than in the past. This type of photograph offered a way for me to develop my reflexes and rely more on my intuition. Within chaos, incongruity and order were established. People as objects and elements were juxtaposed onto backgrounds. The decision and willpower that made me try photographing people resulted in humor being integrated into the images. Now photographs come from responses, not reactions to what I saw. How I used my eye was now far more flexible, and I was integrating the strengths and the different approaches taught me.

Lansing, Michigan. Leica M-3, 35mm Summicron lens, Kodacolor 100

This image is from my first exploration into color photography as a "non-student." Like the shot of the train wheel that follows, it was a part of and a tangible result of the learning process about color. It is a touch too obvious and simple to be anything more than representative of an experimentation. The surrealism, the similar subject matter, and the design sense is repeated from earlier images. Use and sense of color have not been developed or refined enough to create a more complete image, but the limitation of the film and vivid color is being explored.

Jamaica. Nikon F-2, 28mm lens, Kodachrome 64

Guadaloupe. Nikon F-2, 100mm macro lens, Kodachrome 64

△ As time passed and countless images were tossed headfirst into the trash can, a process of synthesis, refinement, and sensitivity for color began to unfold. As I became more comfortable with the color process, my focus again turned to documentary images.

Once color was explored with the same tests done in black-and-white, confidence resulted. The subjects have varied over time, but the threads that were seen in the earliest shots are still repeated. A certain consistency in style and vision remains intact.

This shot has a quality that is reminiscent of a snapshot from a vacation. It has bright sun, blue sky, and clear green water with palm trees. Instead of trees framing the scene of family or friend next to a new car, a weather-worn stripped car with one intact window rolled up is pictured. Incongruity, due to the juxtaposition of the elements and expectation of what the scene should be, result in a humorous image. Harsh mid-day light enhances texture in the car and sand. This is one logical and possible evolution from the first shots.

The refining of visual characteristics taken from the early shot of the railings and applied to the present shot is evident. It is a stylized vision that is graphic in nature and more European in use of color. Subjects may vary (though doors and fences retain interest), but the consistency in design and style is evident.

Symmetry creates a balance and visual rhythm in this image. Selective use of color combines with a graphic and tactile quality. Light-to-dark relationships are reversed on either side of the frame.

TIMELY VS. TIMELESS

Visual images have an effect on the viewer. Whether the images are movies, paintings, or photographs, two kinds of responses are possible. The effect is either timely or timeless.

One way to explain this difference between the two is to look at your response to a movie. Certain movies, entertaining though they may be, do not require much more than cursory attention on the part of you, the viewer. You are a detached observer being entertained, but not much more than that. Occasionally, however, a movie may capture not only your undivided attention, but your senses as well. In doing so, you are drawn into the movie; it is experienced rather than observed. The passage of time as well as ordinary theater distractions are no longer evident. An awareness of the medium of the film vanishes as your involvement with the emotional experience of the film intensifies. These rare movies could be called timeless.

In all art forms, timeless images are vastly outnumbered by the timely ones.

The perception is subjective, and each is necessary to define the other. Both have an intrinsic value, only the perception in experience varies.

For the photographer, the difficulty is compounded by the universal use of the medium. Today almost every household has a "photographer." Also, the photograph is an unmoving, still translation of reality. A sense of wonder or of the unseen has to be present to convey a timeless quality. The image must go beyond being a photograph by becoming a separate reality.

In effect, this is what a photograph can be. The possibility to touch the viewer and have the image last longer than the time it takes to read it does exist. Usually, timely and timeless are defined as either having value that is of the moment or value that stands the test of time. For that to occur or not depends on the effects the image creates. It means the subjective response has a universal appeal. Without doubt, it is a level that many seek, but few attain.

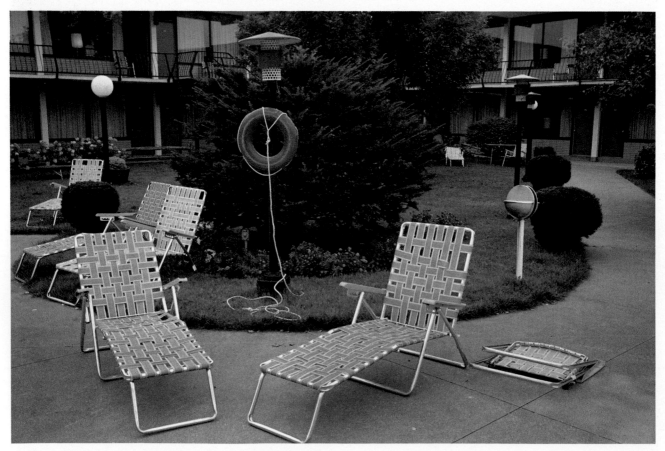

Quebec, Canada. Leica M-3, 33mm Summicron lens, Kodacolor 100

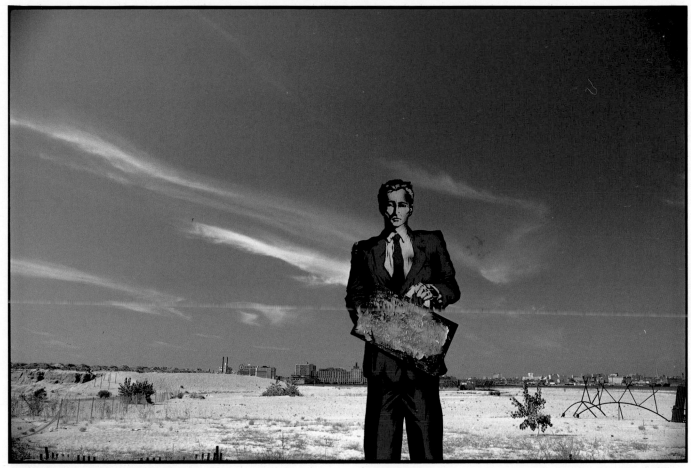

New York. Nikon F, 28mm lens, Kodachrome 64

◁ A clever and amusing quality is offered by the photograph. Chaos, not usually seen at hotels, "arranges" inanimate objects together in a seemingly conversational arrangement. While design, use of color, as well as visual motion are applied well, it is a scene that is observed or read with a certain detachment. Its irony and strengths don't draw me beyond that point.

A certain dynamism is lacking to draw the viewer into the scene. Subtlety and use of color could maintain interest beyond mere observation, but the viewer is required to look for it. It is the photograph which must initially attract attention, not rely on the viewer to look for its value just because it is there.

In terms of the stricter definition of timely, this image, while curious and interesting, would not last long on my walls. At the time it was shot, I enjoyed its humorous value. I still do, but not in a way that I could live with it for a long time.

△ The feeling of actually standing in this bewildering scene is evident. It is and becomes a separate, incongruous, and contradictory reality. A world is seen in a new way and invites participation and scrutiny. Time and medium are frames of reference. The medium is the form that it has, but it takes the viewer beyond that.

At first the contrast of tone strikes the eye. Then incongruity is measured against the subtle relationships of texture, motion, and color that maintain visual motion.

In terms of the more popular definition, this photograph has held the test of time for me. I still see more in the imperfect strained realities of this shot. Living with it on a wall would be possible, but not hung over my bed.

PHOTOGRAPHER'S PHOTOGRAPHS

To maintain sanity, a photographer must divide his images into different categories. Depending on the level of organization and interests, these can include personal, commercial, travel, stock, and so forth. Groups of photographs may overlap these categories. Usually, some have no particular value to anyone but the photographer and his peers. This does not diminish their worth; it only defines the audience that will most appreciate the images. A photographer's photograph is one where the image is appreciated for its application and use of the medium and process. Boundaries within the process are pushed to a different level and consequently re-defined.

Sometimes these images (very few) go beyond the appreciation of just the photographer and peers, to be seen in a different way. However, this is a very special image. For a photographer continuously to walk this fine line of satisfying both groups, your peers and the public, requires timing, luck, and integrity. It is a vision and way of seeing that is consistent and continuous. Such photographers as Irving Penn, Richard Avedon, Harry Callahan and Joel Meyerowitz, to name a few, have this quality. The integrity of their vision is shown in different ways. Harry Callahan's work is for himself, and his commitment to growth has created a diverse group of images. Meyerowitz has this same commitment to himself, but he works commercially to support his endeavors, unlike Callahan. Meyerowitz produces two groups of images that are usually so different that they look like two separate people made them. His division of these two areas by different styles allows him to define the two, and he is successful in both. Penn and Avedon are unique by virtue of their acceptance commercially, artistically, and photographically with no alteration in their vision or their style.

All four have integrity; only how they have chosen to maintain and apply it differs. None of the choices is superior to another; it is a matter of personal choice and character. The one quality that defines all of them is that their vision has changed and evolved by their personal choice and control, not due to external forces or accolades.

Miami, Florida. Rolleiflex 2¼"-square camera, 3.5 Zeiss Planar lens, Tri-X Pan Professional

Although compression is played with and used in this image, the subtle yet wide range of tone is the element of primary importance. An endless range of shapes and textures occur throughout this figure/ground flip. An image of texture and tone is conveyed with a fluid and balanced visual motion.

The value of this image, aside from its strong use of the process, is more personal in nature. Other shots that I have done are figure/ground flips, and rely on texture, subtlety, and clouds as primary elements. But this image focuses only on these elements. I have a strong affinity for clouds due to the endless changes of shape, texture, and contrast that they create. My sense of touch is very important to me, so the visual translation of this sense plays a continuing role in many of my photographs. In a way, this image gives me most of the elements that have significance—texture, clouds, figure/ground flip, and a wide range of tone—and uses the limitations and contradictions that are inherent in photography and perception.

Atlantic City, New Jersey. Nikon F, 100mm macro lens, Kodachrome 64

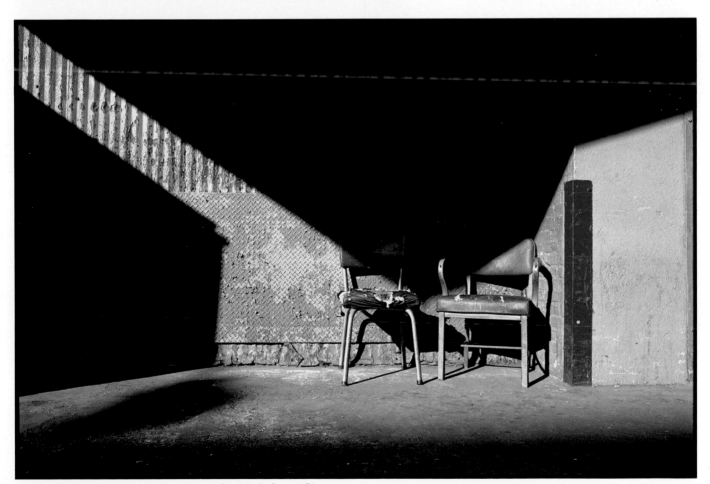

New York, New York. Nikon F, 100mm macro lens, Kodachrome 64

Unlike the other two images, the focus is the importance of light and the effects that are created. The latitude of the film and light work together to define area, texture, and color. The deep shadows define the edges and shapes, and frame the area where light is present. Color and light create a contrast that makes the weathered quality of the elements in the scene seem time-worn rather than neglected and decaying. This contrast defines space, time, and depth, and makes it appear as more than it is. A symbolic quality or imagined story is described by this place in the sun. Over the years, it is possible to imagine, the same two guys have sat on the same two chairs, talking, thinking, and passing the time of day. Using light and color, this image communicates sparingly, and implies details and scenes that are as visible as the detail in the shadows.

Part Six

PHOTOGRAPHING FOR COMMERCIAL APPLICATIONS

Nikon F2, 100mm macro lens, Kodachrome 64

*"The photographer is hired
to control the uncontrollable."*

A commercial photographer is hired to communicate something specific, a client's idea. Whether to inform, to glorify, to illustrate, to dramatize, or to reinforce a concept, the responsibility is to translate the client's vision to film. From experience, I have found that my client's needs are satisfied when I meet my own expectations and my own standards. However, a commercial photographer is paid to create visually for someone else. So, the photographer does answer to someone else and is required to meet the expectations of that client. Whatever type of commercial photography you choose, remember it is disposable art on two levels. First, brochures, annual reports, and advertisements only run for a limited amount of time, and then they are discarded. Secondly, their purpose and their design are specific, but secondary to their usage. For example, a photograph used for an advertisement glorifies a product in some way. Although it is a tool utilized to visually communicate a concept, there have been advertising photographs that have attained the level of art. Yet, the photograph is secondary to the concept, which is designed to create sales. There are numerous bonuses that I have found in doing commercial work. Aside from getting paid to do what I love to do, take pictures, the money I make allows me to shoot pictures for myself. Commercial photography offers the opportunity to see the world as well as to learn about industrial processes and people from other lands. Also, interaction with other creative people offers different views of the world, and therefore, adds to my creativity.

From a design perspective, there are numerous advantages to shooting for clients that make a photographer's job easier. Format choice (35mm—8 × 10) is determined by the subject, size of working area, and the final usage of the photograph. The space within the frame is determined beforehand. Whether usage will be horizontal or vertical, as well as the space for headline/title and/or body copy is marked out. Subject and the purpose of what is being communicated are already decided.

A commercial photographer is only as good as the last photograph. Maintaining a proper perspective between being confident and egotistical is necessary. Since this is a service/product business, you must maintain a professional attitude at all times. Simply stated, the role and the responsibility of a commercial photographer is to solve visual problems. Aside from style, technique, and technical proficiency, other qualities must be cultivated if you are to succeed. Motivation, patience, efficiency, politeness, and enthusiasm are useful along with the ability to listen, to take risks, and to be wily in your approach.

A professional does a job in the best way possible with no excuses offered. The shortness of time, the complex logistics, and any other problems are secondary to the final result. Consequently, it is a business where the unreasonable and the absurd are the norm. It is a separate world unto itself. The same holds true for any creative field from music to movies, theater to journalism.

There are excellent commercial photographers, yet I would not say that they are excellent photographers. True, they have achieved a level of excellence in commercial communication. A photographer shoots to satisfy himself whether on assignment or for personal work. In essence, a photographer has a passion and love for what he does, with process of primary importance, and the product is tangible evidence of evolution.

Over the years, I have heard many claim that their commercial field was art and all others were irrelevant and inferior. At the very least, this viewpoint is as limited as the photographs that are taken by the people who make such statements. Many art photographers have their own peculiar view of commercial work. They view it as a sign of a genetic flaw, lack of integrity, and so forth. From personal experience, I have found that financial suffering was not the key to great art. It only created great discomfort and made the purchase of supplies very difficult.

ADVERTISING

Advertising photography involves the creation of perfection, beauty, and illusion with the addition of nuance. As Steve Adams, art director, states: "A photographer takes the abstract on paper and brings it to life, making it real." From a layout, art director and photographer work together to create a visual image that fits the purpose of the ad. The collaboration of the art director and photographer is more important than the technique of the shot.

The importance of photography can be underestimated and overemphasized. A great visual cannot make a mediocre idea work. On the other hand, a less than perfect photograph can severely reduce a great concept. To communicate effectively, the ad must be complete from concept to headline, body copy to photography, and overall design. As David Nathanson, art director, states: "All of the elements in a print ad are part of the visual language. All have equal value. If not, it is similar to the effectiveness of a car with three wheels." Yet, it is the concept that comes first. Because photography is a tool that an art director uses to illustrate and support an idea and concept, this section will treat the idea of translating that idea into a reality.

For the photographer, the job is multi-dimensional. First, the layout is discussed and communication is established between photographer and art director. Sometimes, what is rendered in the layout contains more perspectives than can be photographed on one piece of film. Compromise and ingenuity are necessary to come up with a satisfactory result. Depending on the job, the photographer then assembles the resources—models, stylists, assistants, set builders, location scouts, color labs, and messengers—to name a few. The talents of these people are critical to the execution of a shot even though the photographer is ultimately responsible. Complicated logistics, tight timetables, and the ability to make the impossible into a reality are all constraints in advertising. Regardless, the goal remains the same, to take an idea and bring it to another level. "A photographer should create an image that is better than what was imagined by adding something that the mind didn't perceive," states David Nathanson.

An awareness of the frame of the ad and the space to be filled with photo, headline, and body copy are necessary design considerations. Granted, the art director does design the ad's final form, but it is also the photographer's responsibility to create a visual that works within that framework.

For the commercial photographer, the work is produced either in the studio or on location. When on location, you create a studio. Given this situation, the possibility of adding something more to the idea or to the image is greatly enhanced. On the other hand, the client fears that it is an uncontrolled environment. Though understandable, the photographer is hired to control the uncontrollable, except, of course, the weather.

In the studio, total control is possible, and the result is predictable. The key is to take this situation and create something more out of it. Lighting, design, and placement of elements are the tools employed. For the clients, a predictable result is desired and guaranteed. The small things—a silver reflector moved, glycerin on a glass rim, the slight turning of the product—will make a shot special. The approach is very different, and yet similar, to shooting on location.

In terms of final image, the studio shot appears to be more contrived. A location shot, with or without product, tends to be more natural and real. In certain circumstances, such as a "pouring" of liquid against a plain white background, any place other than a studio would be illogical. The choice of location or studio is determined by the subject, the size, its availability, the usage, and of course, the budget.

Rich Ferrante, art director, explains the idea behind execution of this ad: "The market is defined as being tasteful, upscale and contemporary. Conceptually, the ad states that now you own the perfect product (the bottle), then decorate around it. In addition, it presents the two perfect objects that you would want to own. To reflect the taste and style that it takes to know and buy this product, the perfect location had to be found. The bottle has a distinctive shape which needed to be played up while the house is played down. What was required and found was a contemporary white interior, simple in style, graphic in design, a minimum of details that would relate to the upscale consumers. It had to be as perfect as the bottle to reinforce the statement of image and prestige. At the same time, it could not overwhelm the product but support it and bring the two stories together."

A thorough location search was done to find the house that fit the criteria of the ad. Existing photographs of the house gave the impression that the entire interior looked like this shot. Upon arrival, we found that only half the house was usable. When location work is done, no matter how thorough you are, you must expect the unexpected and do the job you came for. This collaborative effort was a result of hard work, calm nerves, a positive attitude, and a bit of luck. Although the house looks vacant, it was fully furnished when we arrived.

To create the feeling of space, a low camera angle and wide-angle lens were used. A large space around the product gives it more visual impact. To create further visual discrimination a silver card was placed behind the bottle to increase contrast and to emphasize the lack of color in the background.

As you look at the floor, it becomes clear that it is the graphic quality that helps facilitate movement from front to back. The similarity of triangular and rectangular shapes is repeated throughout the frame. The proximity of bottle neck to the corner of the wall helps enhance motion. Although visual movement around frame is strong, your eye is always led back to the bottle, which is obviously what was intended.

Nikon F2, 28mm lens, Kodachrome 64

Ar Director: Richard Ferrante. Creative Director: Murray Klein. Agency: Smith/Greenland

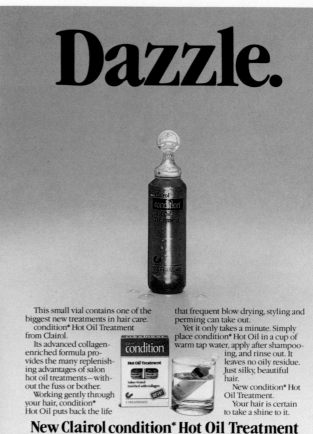

Sinar 4 × 5 Camera, Schneider Symmar 210mm and 150mm lenses, Ektachrome Professional Film

Art Director: Matt Haligman. Creative Director: Bob Dion. Agency: Chiat/Day New York

This is a radical departure from most ads done for this particular product. As Matt Haligman, the art director, states: "It is an informative ad (it teaches) as opposed to an aspirational approach where you show beautiful hair with the inset of the product. The left-hand side shows the problem, while the solution is offered on the right. All primary elements are included to change people's attitude to the product." The elements are the product in use and the product as hero.

In addition, Matt Haligman had to consider the placement of the ad and its effect on the design. He had to think of a concept with a visual that would come across strongly with editorial copy around it. His solution is this graphic and colorful ad that "is believable and treats the consumer as intelligent."

For the left side of the ad to communicate clearly, there had to be "ordered" chaos. As Matt said, "Chaos without order would only result in confusion and you would have difficulty in seeing the message of the ad."

The volume and the color of the products creates the chaos while the sense of order is created by the circular visual motion—all elements leading back to the hair dryer. Additional tension is created by having the elements cropped on all sides of the frame except for the top. The eye is allowed to move up to the headline and rest—a break from the strong shapes, colors, and textures. The simplicity of the right side contrasted by the chaos makes the product visually stronger. Reflecting light through the bottle while leaving space around it further emphasizes the eye's movement to the product.

This ad is the result of a joint collaboration between the art director and myself. Since both of us wanted to add to our portfolios we decided to create an ad together. As art director, Jeff Yates explained, "The restrictions when working for yourself are less prohibitive. At the same time, it is more challenging and difficult because you have to create your own boundaries."

The usage shown is not functional, but since the end benefit is already known, creative license was taken. The concept in the ad is simple and more universal. As Jeff recalls, "This collaboration was a five-minute whirlwind of free association. The end product may not be logical, but the ad works and that is all that matters."

The creation of this shot was an exercise in patience. First, the top of the bag was suspended with wires (later retouched out) to compensate for the weight of the water. Second, a dark background (which was water-resistant) was selected to highlight the subject. Third, the fish had to be kept alive, and yet, be made to swim in the bag. Endless hours were spent taking the fish out of the bag (so he could breathe), refilling and drying the outside of the bag, and shooting again. Gentle prodding with a pencil from underneath the bag made the fish swim. Top lighting highlights the bag's form and the contents. Notice that the bottom of the bag barely touches the surface, giving the impression of the strength of construction.

The visual plays off the concept. Lots of space surrounds the bag so that it floats and emphasizes product usage. The headline serves as an anchor for the concept. As the art director, points out, "When the consumer is shopping, you want them to remember the fish in the bag and have the product at the top of their shopping list." Using a light background would have visually reduced the importance of the product and its usage.

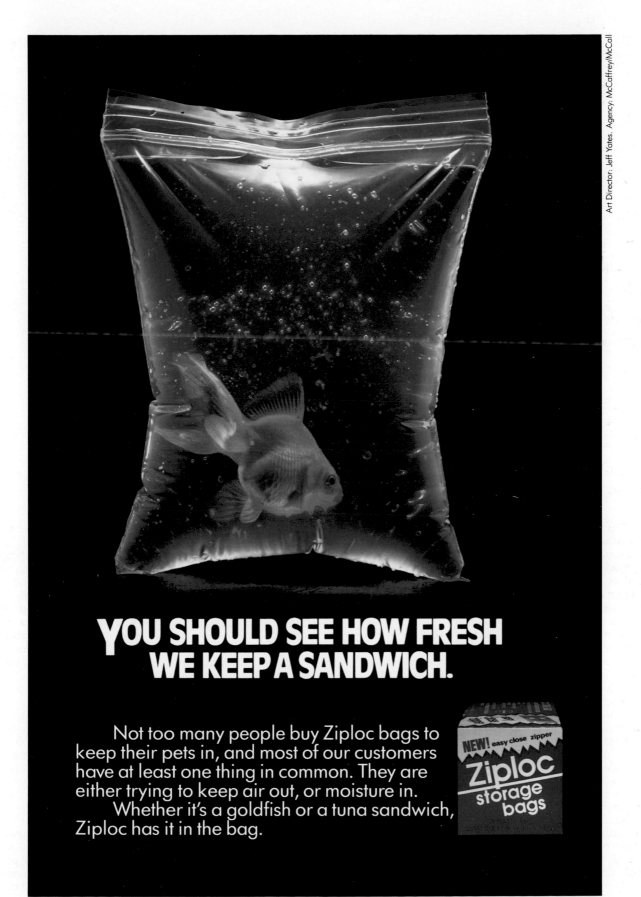

YOU SHOULD SEE HOW FRESH WE KEEP A SANDWICH.

Not too many people buy Ziploc bags to keep their pets in, and most of our customers have at least one thing in common. They are either trying to keep air out, or moisture in.

Whether it's a goldfish or a tuna sandwich, Ziploc has it in the bag.

NEW! easy close zipper
Ziploc
storage
bags

Hasselblad 2¼"-square, 120mm lens, Ektachrome 64 Professional Film

The introduction of a "new product" is a difficult task. Steve Adams, the art director, had to "make it new without saying it, because when people see the word 'new' they assume that it isn't." In addition, he had to examine the magazines in which the ads would be placed. After careful research he concluded that "most of the ads were overly cluttered. The most effective approach was to create a simply designed ad with a graphic style. A contemporary look would result and its simplicity would make it stand apart from the others. To make a flashy introduction would only muddle the story and it would have been just like any other ad in the magazine. One advantage that we had to work with was the design of logo and type for the ads and company. Type design and the visual structure of the ad work together to reflect the new technology. This is necessary to maintain for the future, but the consumer campaign will be more humanly oriented as opposed to the technical."

The primary basis for judgment on how well an ad works is sales and inquiries. As Steve stated: "Since the ads ran, inquiries are running at 50–75 per day and the advertising budget has increased. So, we must have done something right!"

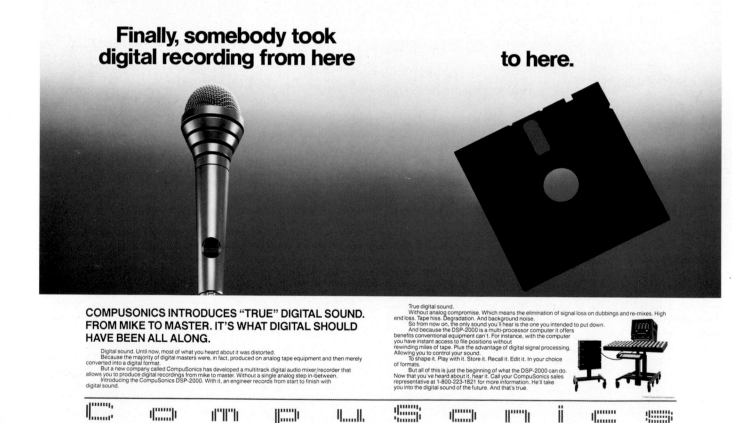

Sinar 4×5 Camera, 210 Schneider Symmar lens, Ektachrome Professional Film

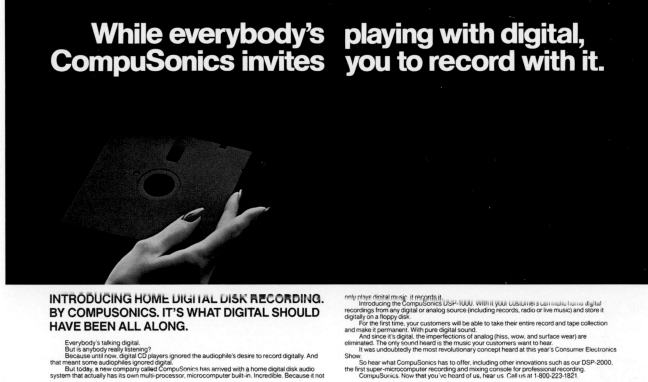

Art Director: Steve Adams. Creative Director: Jack Silverman. Agency: Leber Katz Partners

Sinar 4 × 5 camera, 210 Schneider Symmar lens, Ektachrome Professional Film

◁ The purpose of this ad was to appeal to engineers who know the technology and its benefits. "Since the industry knows why it is good, we needed to get their attention and say that the technology is here now and we have perfected it." By utilizing only two visual elements with a strong usage of contrast and space, the ad grabs your attention. The white top of the ad provides a good contrast for the type. Visually, the mike and disk seem to float up to the headline which in turn acts as the way to anchor the eye from going off the frame at the top.

Image and headline are integrally related. The background gradation of light-to-dark is visually strong because it increases the headline's strength. On another level, it works because it is the reverse of how we perceive light at the horizon. At sunrise or sunset, it is lighter at the horizon and then becomes darker in tone. Proximity and contrast enhance the movement of visual to headline, and back again.

△ Because this is a retail ad, it is necessary to include the human element. The ad also has to create intrigue about the product to stimulate dealer interest. "The other difficulty we faced was the introduction of a new technology not unlike the arrival of tape many years ago. These ads had to interest and not scare them. To overcome people's initial hesitation towards new technology, the ad had to interest and then educate them to the superior technology. People are aware of the floppy disk but not its use in this way," recalls Steve.

Visually, this is a refreshing approach to introduce recording equipment. The edge of the component, functions, and lights, are all that define the equipment. Showing less peaks interest. The hand placing the disk into the deck defines depth and acts as a visual anchor so that the deck doesn't appear to float in space. The red polish on the nails is answered in the glowing lights. Simple and distinctive, it is an example of less being more.

This trade campaign was a new venture for both client and agency in many ways. Two companies had merged and a new series of ads had to be created. For art director David Nathanson, "this meant the birth of a new design and look for the advertising." When a new campaign is created, client and agency have many issues to consider.

The insurance business is very complex. Each division has many virtues, but is it necessary to determine the strengths and weaknesses of the business to design an effective advertisement. At the same time, the agency must maintain a clear vision of what the client stands for. As David indicates, "In a campaign, information has to be reduced to bite-size pieces. You have to nail down the important points to be persuasive and help people understand. Naturally, you strive to communicate in a simple, distinct and coherent way which would result in a preemptive way of selling. Ideally, your market would see all of the ads, but you cannot rely on this hope. So, each ad should be like the pieces of a puzzle that fit together. Here, the sum is greater than the parts with each part having the strength to stand on its own."

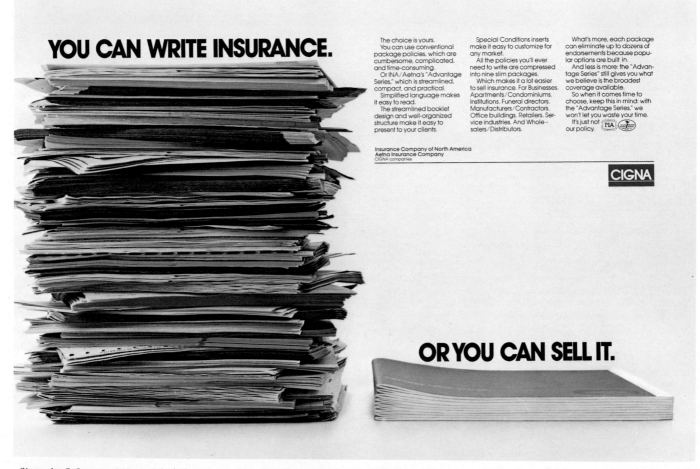

Sinar 4×5 Camera, 150mm Schneider Symmar lens, Ektachrome Professional Film

A photographer must make the shot work within the context of the ad. In this case, the difficulty was two-fold. Due to the concept of the ad and the difference in size of the two piles of paper, I decided that dramatic lighting was inappropriate. Also, the colors in both piles were supposed to read strongly. As a result, a soft sidelight was used to highlight color and texture, and not detract from the scale comparison. Only the organization of the chaos on the left remained to be altered to create visual motion. Turning the papers askew and placement of colors adds more interest to a mundane subject. Again, look at the visual placement of headline and copy in relation to the photograph. This is a difficult shot to do well, but it is the final design that ties it all together visually and conceptually.

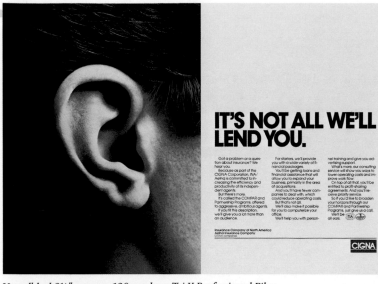

Hasselblad 2¼"-square, 120mm lens, Tri-X Professional Film

Here, the key was to find the perfect ear. A casting was held to locate the male who had such perfection on the right side of his head. Between 20 to 40 hopefuls arrived at the studio, Polaroids were shot, and the decision was made. Originally, this was shot in black-and-white because it was felt that the realism of color would be overwhelming. Later, the print was sepia-toned to give the image some warmth. Sidelighting was used to highlight the shape and contour of the ear. Hair on the head and the line of the jaw were included so that it would be real as opposed to being an abstract shape. This ad has a different design than the others. Design was altered to fit the ad, not reduced to look like the others for the sake of apparent continuity.

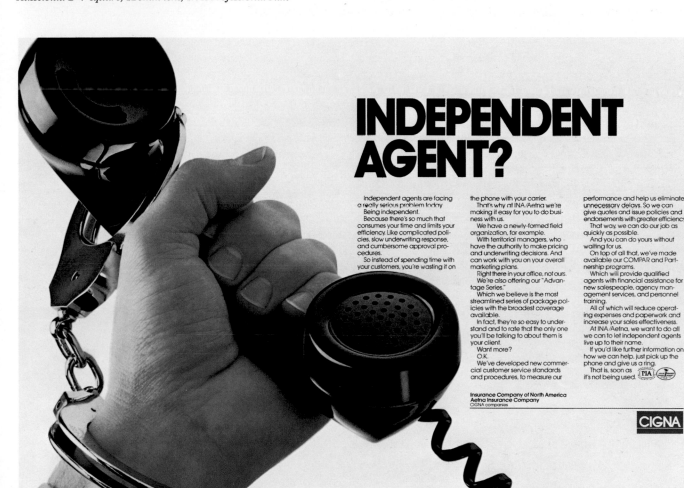

Sinar 4×5 Camera, 210 Schneider Symmar lens, Ektachrome Professional Film

This is a perfect example of the art director making the photographer look good by using a strong, well thought out design. The phone is cropped at the top; tension is shown in a taut cord, and the mouthpiece is surrounded by type. These elements add to the obvious tension of the tightly gripped hand cuffed to a phone. Positioning of the hand and phone suggests that it is either being picked up or put down. Regardless, the agent is handcuffed.

For this ad, a separate casting was held. The hand had to be masculine, strong, and smaller than the phone. A selection of handcuffs were bought and the black phone (for contrast) was rented. The result is clean, distinctive, and communicates clearly.

INDUSTRIAL

Compared to advertising photography, the design considerations for industrial work are much simpler. The photographer must still be aware of framing, cropping for reproduction, format necessary for reproduction, and sometimes the placement of the headline within the frame. Although the picture must describe and communicate a specific point, the image produced does not have as many conceptual constraints as those found in advertising. The purpose is to take the ordinary, and glorify and aggrandize it so that the subject appears to be more than it is. Both the purpose and challenge for the photographer is to take the mundane and render it in a way that is special. In its essence, the role of the photographer in advertising and industrial is very similar. However, industrial work presents fewer visual and conceptual boundaries to work within because there is no limiting advertising concept. The work usually appears in annual reports or company brochures.

Unlike the advertising photographer, the industrial photographer usually does not know what the subject looks like until he arrives at the location. Approach to a new subject varies from person to person; some go in with motor drives blazing. I prefer to take a quick walk through the area, pick my shots out, think them out, and then commence shooting. Neither approach is superior to the other, but I feel confident in my vision. I don't consider a volume of shots to be superior to a smaller group of higher quality images. Regardless of approach, the photographer must cover the subject completely, and give the art director or designer a choice.

Again the constant, as in other commercial work, is the element of time. In industrial work, the wait can be for a busy executive or a lunch break so you can shut down an area of a factory without disturbing production. Hurry up and wait is the motto of the commercial photographer.

An industrial photographer must be a combination of a diplomat, a fast thinker, a coordinator, and a controller of people and of situations. The photographer has one eye on the clock, and the other watching to see what comes next. In addition to these qualities, the realization that your presence affects the workday routine is very important. An instrusion and a breakup of routine is inevitable. If you show concern for this disruption and are courteous, most people will be helpful. Advance communications with foremen and supervisors will further assist you in getting the job done. Sometimes neither approach is successful, so other tactics may be necessary to get the shot. The bottom line is to get not only the shot, but the best possible rendering of what was there and could be imagined.

Since these railroad spikes were being created inside the furnace, the trick was deciding how to photograph them to make them look dynamic. The best vantage point was looking into the furnace as the spikes were being washed down to cool them after being cut.

A telephoto lens was used to increase image size and to insure that my camera and I did not melt. On a signal, a belt was stopped to allow the hot spikes to pile up as the water continued to wash over them. Water motion was stopped by the use of an electronic flash from above. By using selective focus, the shot informs without being unnecessarily repetitive. The dark out-of-focus background highlights the hot spikes. The heat of the spikes is shown by the color; the cascading water "describes" the process.

Art Director: Patty Aljo. Client: Gold Fields Mining, Amcon Annual Report

Nikon F, 200mm lens, Kodachrome 25

Nikon F-2, 100mm lens, Kodachrome 64

When not on assignment, I try to spend as much time as I can wandering around shooting pictures for pleasure. After a stimulating hour in a bus parking lot, I noticed a set of gas tanks. This shot was a result of my curiosity.

Symmetry and repetition of similar shape create the motion. The placement of tubes over the type enhances up-and-down movement and makes the type a visual anchor. Without the type, the shot becomes reduced to a white wall with tubes. Put your finger over the type and see how quickly it changes the shot. Now, look at the gauge. The tilt of the gauge and the pointing of the arrow in a similar direction to the tubes further adds to the movement. This may seem minor, but if the arrow were pointing to the right, it would point the eye to empty space and abort movement. Your eye would be stuck on the gauge.

Sometimes the industrial photographer is faced with shooting a subject that, for whatever reason, does not really exist at the time he arrives on location. Ingenuity, composure, and patience are necessary to deal with this situation. In this photograph, the panels are mounted on a plywood frame and black seamless covers the areas in-between the plates. Temporary electrical connections were made to light up the bulbs.

In addition to these minor inconveniences, the shooting space was so small that it could only be shot from the right or straight-on. A strong sidelight with a blue reflector on the left creates drama and a slight introduction of color. By using a time exposure, the lights on the panel registered on the film. As work continued, it became clear that something else was required to spice it up. By placing a small flash behind the panel and having a person move the panel out of position adds the missing element. The technician is intentionally out-of-focus because it is only necessary for his shape to define him. If he were in focus, it would have pulled the eye away from the panel.

This is a classic example of creating a studio on location and then making something out of nothing.

Hasselblad 2¼"-square camera, 80mm lens, Ektachrome 64 Professional

Creative Director: Ellen Clancy. Client: State Street Bank. Agency: Polese/Clancy, Inc.

After an extensive walk-through of the two factories, it became clear that the photograph was in the product and not in its production. However, the file cabinets being produced that day were not available in a wide range of colors. As a result, it was necessary to focus on the size, shape, light-to-dark relationships, and the space in the products. A combination of the strong lighting and the placement of the files makes a somewhat abstract, yet still recognizable image.

The lighting creates a strong feeling of line, shape, and depth. Repetition of the files informs the viewer that they are made in various sizes. Two small electronic flashes provided the light in-between the cabinets and on the small, black file in the foreground. This separates and defines the space, edge, and the distance between foreground and background.

Creative Director: Ellen Clancy. Client: State Street Bank. Agency: Polese/Clancy, Inc.

Hasselblad 2¼"-square camera, 120mm lens, Ektachrome 64 Professional

▷ An assignment like this is a photographer's dream. Just put up a couple of lights, click the shutter, and you have a perfect shot. A minimum amount of time was spent deciding how to use this scene to best communicate information about the client and the importance of the computer.

Repetition in line and shape in front and back are identical. First, look at the computer, the stocks, and the flower in the foreground. In the background, the flowers and the top portion of the computer are included. Contrasting light was used to light the background so your eye will be drawn there. Simply stated, it is a good figure/ground flip.

Hasselblad 2¼"-square camera, 50mm lens, Ektachrome 64 Professional

Art Director: Patty Aljo. Client: Gold Fields Mining. Amcon Annual Report

Nikon F-2, 100mm lens, Kodachrome 64

When shooting away from the studio, you must follow your intuition and wait for a scene to unfold. The art director, assistant, and I were walking through the scrap metal yard with the foreman. From a distance, we saw these welders cutting apart a barge. As we circled the barge, the first shot of the men working came into view. Within a couple of minutes, as they stopped to talk to a supervisor, I moved in closer for the second shot.

There are numerous strengths in the first image that are used in the second. Good front-to-back movement between the workers, and good similarity in shape of triangles and rectangles are evident. Although this image has good contrast and dramatic lighting, the empty space in the center results in your eye being pulled off the top of the frame. It is the use of space that visually makes the difference between the two shots.

By standing up, the workers fill the frame and the shot stops being a literal translation of the scene. Their clothes, environment, helmets, and dirt on faces, define them as men at work. It is a more real and dramatic presentation.

Hasselblad 2¼"-square camera, 150mm lens, Ektachrome 64 Professional

Hasselblad 2¼"-square camera, 50mm lens, Ektachrome 64 Professional

Both of these photographs were done in a plant that made raw wool into bolts of finished fabric. After touring the factory, it was decided that these two approaches to the material said the most about the company and what it produced. The method in which each shot communicates is very different.

The shot of the hand and tweezers on the fabric tells of the process. The selective focus of the telephoto emphasizes the human importance. Natural lighting gave a nice, clean definition to the hand with its diffused quality, adding a soft touch. Contrasty lighting would not have made the hand visually stronger. The focus has already established that fact.

As the telephoto isolates (in the right-hand shot), a wide-angle lens emphasizes the volume and scale of the final product (in the left-hand shot). A contrasting side light, provided by electronic flash, emphasizes the shapes of the rolls and their texture, which is important to convey the nature of the product. Repetition of the shape and the color of wool create motion and give more information about the final product.

In approach, execution, and communication, these photos are totally dissimilar. However, they both inform clearly with strong visual motion.

TRAVEL/LOCATION

Travel photography is very different from the worlds of advertising photography and industrial photography. Many photographers travel with a minimum of gear. A favorite motto is, "If you can't carry it on the plane, then don't bring it." Layers of clothes, small flash units, lenses, camera bodies, a tripod, and more film than you'll need are the basic necessities. Travel photographs should describe, aggrandize, tell a story, and indicate what is special and different about a location and its people. Design and conceptual boundaries are not as confining as in other fields. The photographs are often requested by tourist bureaus or used as promotional ads.

Instead of layouts, the travel photographer is given a list of shots to do that may include landmarks, sports activities, natural wonders, night life, as well as photographing people at work. These are the criteria and boundaries that he must satisfy.

This field offers the best way to see the world and its people. The viewpoint is close, and the understanding and knowledge is vast. Personally, over the years, I have noticed an interesting visual phenomenon. The landscapes of the cities and countryside of the United States are very graphic and angular. On the other hand, European cities and landscapes are more rolling and curving in appearance. It is the travel photographer's work which directly contributes to people's desire to travel. Most people's vision of worlds unseen is a result of an endless curiosity and continuous desire to see, learn and understand the world in which they live.

Endless movement using all forms of transportation, even four-legged creatures, is guaranteed in this field. Useful skills include stamina, patience for the waiting, and respect and sensitivity towards people's beliefs and customs. The ability to read a compass, to read maps and to follow road signs, as well as the ability to speak at least one foreign language fluently, is indispensable. Of course, always carry an American Express card.

On location, luck can be a photographer's friend. As I rested my feet, these children marched out on their break. Fortunately for me, the youngest started screaming, "Picture! Picture!" So his brother and sister were persuaded to pose. The only directions I gave were to put the youngest child in the center and to ask him not to put his hands over his eyes. Both children were carrying items (a book and briefcase) which helps to define them as students.

It is the design tool of framing within a frame that makes this shot work. Only the dirt in the foreground is not framed, and therefore, acts as a necessary visual resting place compared to the fullness of the subject and background. The shot works because the smallest child is framed by brother and sister. She, in turn, is framed by the gate and door frame while her older brother is framed by the top of the gate. They are then framed by the doorway ceilings and pillar. All of these frames form similar shapes, both triangles and rectangles. The direction of the shadows and triangles lead back to the children. Also, the continuation of lines from the tall boy's arm to the book to the briefcase to the little girl's arm helps visual movement.

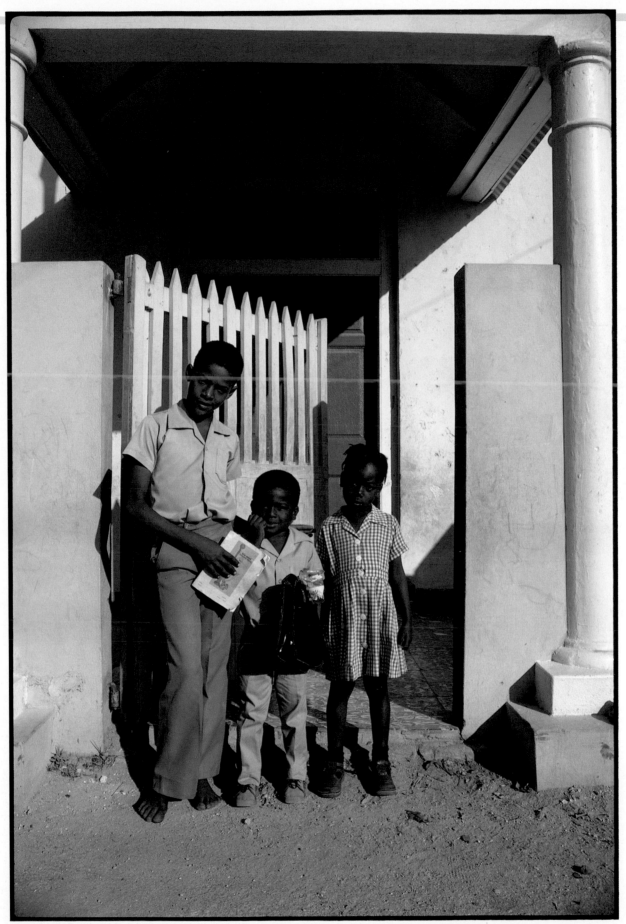

Jamaica. Nikon F-2, 28mm lens, Kodachrome 64

Oisitin, Barbados. Nikon F-2, 28mm lens, Kodachrome 64

△ This image conveys beauty and tranquility, and is descriptive in the process. An obvious relationship exists between the boats on shore and those on the water. But it is the tracks in the sand leading out to sea that really reinforce the relationship between the two and complete the story. A strong motion is created by the boats' placement in the corners. This linear shape and movement is repeated in the shore line, the trees, the clouds, and the sweep (curve of line) of the boats. The feeling of tranquility is created by this gentle motion, a still sea, and a balance in the light-to-dark relationships. As you look at the foreground, you see the right corner is dark and the left corner is light. In the background, the tones are reversed. The top right corner is light while the top left corner is dark. The balance of tonality in each corner creates that peaceful quality. Movement front-to-back is facilitated by seeing the boats as closed and complete, and the reflections of the clouds on the water.

▷ Inclusion of the background in this photograph communicates not only the beauty of the flower but the beauty of its environment. A closeup would have shown a pretty flower, but what would tell the viewer that it was not shot in California? The color of the water and the sky help establish locale.

A polarizing filter was used to darken the sky, control reflections on the water, and increase color rendition. Gentle visual motion combined with the filter's effect help make the shot communicate beauty and serenity. Other visual devices assist in creating motion and interest. The dark line at the horizon seems to divide the image in half. This adds another dimension by creating two pictures that are integrally related. Similarity of shape (wavy lines) is echoed in the clouds, waves in the sea, the shape of flowers, and the curve of the shore line. The similarity between the live red flower and its dead counterpart, and the space and shapes of the puffy clouds in the sky also add to the continuity of the photograph. Contrast and the closure of the flowers highlight them as the subject.

Barbados. Nikon F-2, 28mm lens, Kodachrome 64

Jamaica. Nikon F-2, 35mm lens, Kodachrome 64

The quality of light can be the crucial element in a photograph. Late afternoon light gave this shot the additional boost to make it work. A strong directional light and warm color make the fisherman and his work more special. The flow of light acts as a spotlight. Selective focus emphasizes him, but background is not so out-of-focus that the house and terrain are not discernible. The inclusion of the house and the nets on right informs the viewer of the subject's work and his environment.

The leaves across the top of the frame act to keep your eye in the picture. Try placing a piece of paper over this area and you will see that your eye leaves the frame immediately. Since strong lighting emphasizes shape and form, observe the way the man and the trees on right serve as anchors to balance the frame on each side. The shape and tilt of head and hands communicates concentration and movement.

Jamaica. Nikon F-2, 28mm lens, Kodachrome 64

This shot of a fisherwoman has an almost lyrical tranquility. She is highlighted by her size, the reflection of the cloud on the water, and a strong sidelight. A continuous gentle curved line is echoed throughout the photograph. The impression of absolute silence is created by the glass surface of the water; the quality of light defines it as a quiet time of day.

Yet, it is the element of total balance that creates motion and tranquility. Compare the woman on the right with the way her presence is balanced (through reverse tonality) by the light, the shore, the trees and the space, then formed in the background. Visual balance occurs between the small cloud and the rock in the water just behind the boat. Tones are reversed, but it is the contrast and similarity of shape that allows this grouping of elements. Two points enhance motion. First, shape, texture and tone of clouds are reflected in the water, which helps the eye move from shore to sky and back again. Also, the shapes of the shadows and the logs are repeated on the shore line to bring the eye around to the poles and trees.

It is a beautiful scenic which goes beyond the description of place and people at work.

Grande Terra, Guadaloupe. Nikon F-2, 100mm lens, Kodachrome 64

△ Sometimes while shooting on location, the days can seem to be endless. The light seems to fight you and your sense of direction seems like it has been inside a blender. At the end of such an inspirational day, I came into a town and saw this shot. In this instance, it was a case of waiting for the moment. A five-minute wait gave me the people and positions that worked.

Again, I shot a frame within a frame. The three posts create three frames for three doors for the people, the shutters, and the gumball machines. Motion to the bottom left corner (which acts as a resting place for the eye) is created by the boy looking towards the man. The similarity of color in the red and blue adds to the movement. It is a clean and informative shot that has movement and maintains interest.

▷ Every town, city, and country has landmarks for which it is known. Negril, Jamaica is known for its beaches, sunsets, and lighthouse. For the travel photographer, often the job is to take that which has been shot many times before and add a twist that will make it different. Here my solution was to incorporate the elements—sunset, fauna, and landscape—in order to give the photograph a context and make it say more than, "Here is the lighthouse."

The key, again, is the quality of light and the color of the sunset. Backlighting on the tree and on the house creates a balance for the lighthouse. The leaves in the top right corner fill space so the eye doesn't drift away, while similarity of shape enhances movement.

Jamaica. Nikon F-2, 50mm lens, Kodachrome 64

INDEX